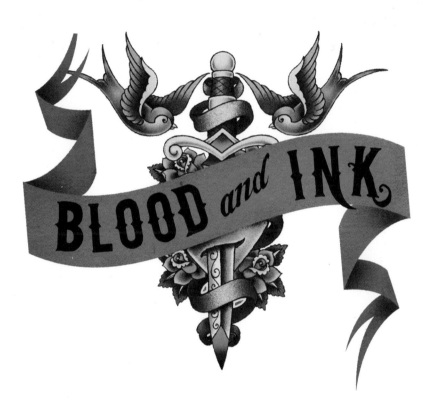

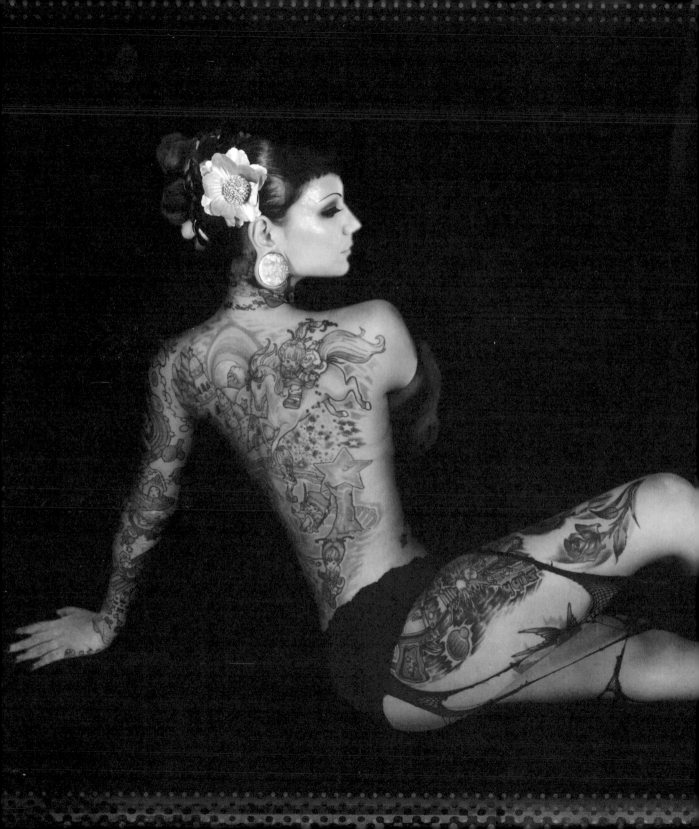

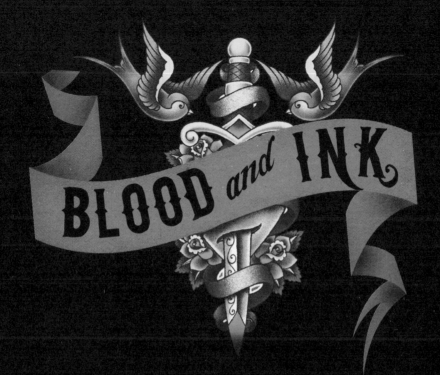

BLOOD and INK

BY RUSS THORNE

RUNNING PRESS
PHILADELPHIA • LONDON

A QUINTET BOOK
Copyright © 2011 Quintet Publishing Limited
First published in the United States of America in 2011 by
Running Press Book Publishers.

10 9 8 7 6 5 4 3 2 1
Digit on the right indicates the number of this printing

ISBN 978-0-7624-4175-4
Library of Congress Control Number: 2010940507

This book was designed and produced by
Quintet Publishing Limited
6 Blundell Street, London N7 9BH

Designer: Ian Ascott
Concept Designer: Zoë White
Proofreader: Liz Jones
Indexer: Asha Savjani
Photographer: Scott Forrester
Art Director: Michael Charles
Managing Editor: Donna Gregory
Publisher: James Tavendale

Running Press Book Publishers
2300 Chestnut Street
Philadelphia, Pennsylvania 19103-4371
Visit us on the web!
www.runningpress.com

Printed in China by 1010 Printing Ltd.

Do not use temporary tattoos on broken or irritated skin, or on the face or neck.

ABOUT THE TEMPORARY TATTOOS:

Ingredients: Polypropylene, Styrene/butadiene Copolymer, Polyvinyl Alcohol, CI 77491 (iron Oxides), CI 45410 (Red 27), CI 47005 (Yellow 10), Acid Blue 9 (Blue 4). Manufactured in China. Batch no: QDBCSR99095

CONTENTS

ABOUT THIS BOOK

The story of tattoos is as old as humanity itself. Before they decorated the arms of celebrities the world over, tattoos were symbols of faith, protection, and even warrior status.

In 3300 BCE, your first experience of tattooing might have been rubbing soot from the fire into fresh wounds made by thorns—that's the theory behind the world's oldest tattoos, found on a Bronze Age man (nicknamed Ötzi) preserved in glacial ice. Later, you might have received a tribal tattoo tapped into your skin using a rakelike instrument with sharp teeth, like the ones Captain Cook found when he showed up in eighteenth-century Polynesia. In the nineteenth century you might have received a traditional Japanese tattoo from a master who was forbidden to tattoo natives in case they were gangsters, and by the beginning of the twentieth century your first encounter with body art might have been accompanied by the distinctive buzz of the tattoo machine.

Now, of course, you see tattoo art on TV, in magazines, on T-shirts, and sometimes even on people. It's everywhere. But one thing hasn't changed across the millennia: You never forget your first tattoo experience. This book exists to make that experience a positive one.

Dave Perry on the appeal of tattoos

"For me, the appeal of tattooing is the extremeness, the f*ck off-ness of it. It's art without an eraser, the most extreme kind you can do; it's definitely not for the faint of heart!

"TV shows over the last few years have made everyone think that you have to have a deep and meaningful reason for getting a tattoo; and that's a nice reason to get one. But there's just as justifiable an argument for getting one because you think it will look great on your skin. It works both ways."

Dave is a master of realistic tattoo art. Visit revolvertattoorooms.co.uk to see his work, and see examples on pages 80–1.

Blood and Ink isn't here to tell you whether or not you should get a tattoo; that's a very personal decision, and making it is part of the fun anyway. You might not even want one—perhaps you're just interested in the art. Either way, with so much choice out there it can be hard to know where to begin. This book is here to introduce you to some of the major schools and styles of tattooing, and point you toward some of the best and most influential tattoo artists working today. You'll learn about the meanings behind some popular images, and get hints and tips from the pros. The more you know about the breadth and depth of the tattooing industry, and the level of skill out there, the more likely you are to get a great first tattoo that you'll enjoy for many years to come.

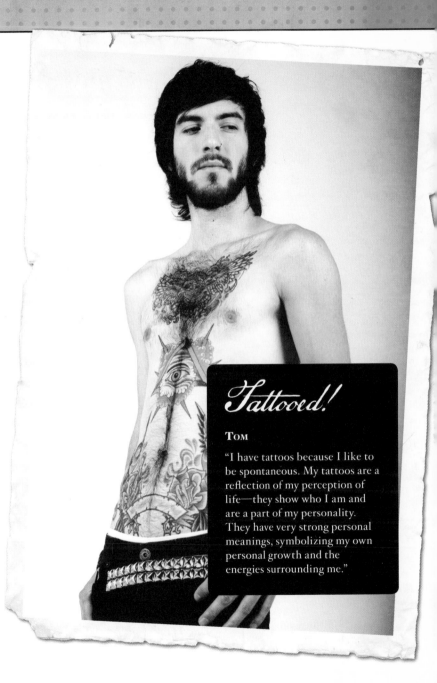

You'll also find some temporary tattoos here. Why, in a book about real tattoos? Well, mainly because it's fun and painless. But also because the designs were all created by real artists working today, so they'll help give you an idea of the kind of tattoos you might like to investigate more fully. And if you can wear a temporary tattoo without scratching it off within a day, you might—might—be ready to handle a real one. Think of it like looking after a Nintendog before you're allowed that puppy.

If you've already got tattoos, there's sure to be something here for you too— inspiration for new ink, comments from top artists, and bits of tattoo history you may not have known. And yes, scantily clad models with body art, if that's your thing (we're not judging).

Ultimately, it boils down to the fact that there are tattoos, and there are great tattoos. You can find the former easily enough; finding the latter is a bit harder. This book is here to help, so you'll join the long line of people throughout human history—kings, queens, warriors, and countless others—who wore their blood and ink with pride.

Tattooed!

TOM

"I have tattoos because I like to be spontaneous. My tattoos are a reflection of my perception of life—they show who I am and are a part of my personality. They have very strong personal meanings, symbolizing my own personal growth and the energies surrounding me."

ABOUT THE TATTOOS

NICK SOLOMON

One of the foremost practitioners of true Western traditional tattooing, Nick "The Tailor" Solomon hones his labor of love six days a week at Beelistic's Tattooing in Cincinnati, Ohio. He studied the fine arts at collegiate level and would be glad to put his knowledge to use for your tattoo.

WILLEM JANSSEN

Willem has been designing for about three years now. His focus is tattoo art: He mainly enjoys doing Old and New School designs, and high-contrast designs with cool colors and different shapes. "I love what I do, I can't imagine doing anything else."

EMELIE JENSEN

A working tattoo designer since 2002, Emelie stopped tattooing about two years ago and decided to stick with just designing tattoos, since this is where she felt her heart truly belongs. "This is what I love, and what I do every day!"

PETER TIKOS

Peter works for several publishing houses, game developers, and advertising agencies worldwide. He mostly illustrates roleplaying and collectible card games like Dungeons & Dragons, Shadowrun, and Rolemaster. In 2004 and 2005 he was voted among The New Masters of Fantasy artists and has been exhibited twice in the NMoF—A Collection of the Year's Best Fantasy Art.

LANDON ARMSTRONG

Landon is an illustrator trapped in the middle of the desert. He loves any project that lets him run free with his style—he finds album covers particularly fun to illustrate when the band's great to work with. Eventually he wants to move his career toward fine art.

JANE LAURIE

Jane spends most of her time drawing birds, and if she is not drawing them she will be outside with a pair of binoculars trying to find them. As well as illustration, Jane has also been involved with the design of interactive installation visuals, stage show design in London's West End, and stage imagery for pop star Mika. She is addicted to tattoos and has many plans to cover herself in more of them.

MOLLY CRABAPPLE

Molly Crabapple is a native New Yorker and caffeine addict. She's known for hyper-detailed, saucy Victorian illustrations for clients like DC Comics, Marvel Comics, and *The New York Times*, as well as notorious nightclub The Box. Molly is also the founder of Dr. Sketchy's Anti-Art School, an alt-drawing salon with branches in over 100 cities around the world. She ran away to Paris at age 17 "and figured things out from there."

HOW TO APPLY THE TEMPORARY TATTOOS

1 First, choose your tattoo design from the 5 tear-out pages at the back of this book, and then select the position on your body that you'd like the tattoo to be placed on. Do not use on broken or irritated skin, or on the face or neck. Clean and dry the skin around the chosen area completely. Cut out the design of your choice and remove the transparent film.

2 Place the tattoo face-down on the skin. You may need to get a friend to help you out with tattoos on your back. Wet the tattoo completely with a damp cloth or sponge. Press down quite hard and evenly across the design for a few seconds.

3 Peel the corner of the tattoo back gently to check if it has transferred. If it hasn't completely transferred, wet again and press down. Your tattoo can last for several days if transferred carefully and looked after.

4 Your temporary tattoo will fade naturally over up to a week. To leave it in peak condition, try not to wash the area too much, and don't exfoliate. Clothes rubbing on it will also speed up its deterioration. To remove the tattoo gently, wipe with cold cream or baby oil. Rubbing alcohol will remove the tattoo instantly.

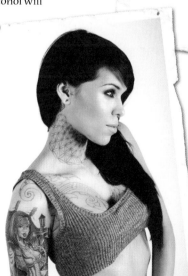

Tattooed!

ARABELLA

"To put it simply—I have always preferred skin with ink! I have to admit there isn't anything personal about my tattoos other than the fact I just love them! I love the art and really respect the artists."

Tattooed!

AARON

"I've always loved the interest tattoos provoke. I also love the process; it's extremely artistic and creative—whether you design your tattoos yourself or work with your tattooist to achieve your perfect design."

TATTOOS TODAY

Sion Smith, editor of *Skin Deep* magazine, gives us his impressions of the tattoo world at the beginning of the twenty-first century, as well as some tips for your first tattoo.

"Tattooing is a little bit like the Internet: It was once the domain of the few. Now, especially in the last couple of years, it's become very mainstream. Some artists like it; it's good for business. And some don't—it's taking it out of the 'specialist' realm.

"Globally, tattooing is very healthy. It's not without its problems, but everyone's doing just fine. I recently had to make the division in my own head that there are tattooists, and there are tattoo artists—and the two are massively different. It's like a barber or a hair stylist; it's really different. I'm not sure if the general public are aware of that, but it's certainly the way it is.

"It's also definitely the case that a lot more artists are coming through now who have been classically trained. Simone and Volko (Buena Vista Tattoo Club, see page 57) did 12 years of art school before they decided to take it into tattooing. And why not? It's hard to make a living as an artist, but you can transfer the skills to tattooing and do really well.

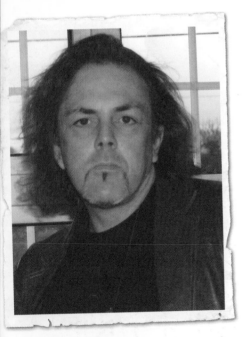

"I do think that surly, intimidating tattoo studios will gradually be weeded out as a matter of evolution. If there's a burly tattooist in one place, but less than a mile away there's someone with a pristine studio who's very nice, the burly guy will soon find himself left behind."

CHANGING TIMES

"Society changes. I did an interview recently with a part-time tattoo model who's a nurse in her day-to-day job and asked her if she still encountered preconceptions based on her tattoos, and she said 'Yes, but I'm glad I'm like this. One by one, you dispel the myth: I'm a nice person even though I've got full-sleeve tattoos.' It's pretty normal to have them now.

Top right: Simone and Volko of Buena Vista Tattoo Club are among the new wave of pioneering tattoo artists.
Left: Sion Smith, Skin Deep *editor, has followed how popular perceptions of body art have changed during the last decade.*

Boff Konkerz on the future for ink

"As any industry grows it diversifies, and that's what's happening with tattooing now. In the future we will have more styles and techniques to choose from—it's been happening in tattooing for a while and is an ongoing process." **(See page 52 for more Boff.)**

"However, I think a full sleeve when you're 19 is too much. Yes, it can work for a minority, but I see pictures of students with full neck and throat pieces and I think it's too much, too soon. When you're 30-odd, employed, making a go of things, that's fine—but if you've just got your degree, and you have a tattooed neck, that might well present you with problems."

GETTING A TATTOO

"The first bit of advice when planning a tattoo is to go somewhere professional. Do it properly. You can get a good feel from going into a studio about whether it's going to suit you or not.

"As for getting your first one, be true to yourself. Get something you'll be proud of when you come out of the studio. I don't think you get a tattoo with the intention of it standing the test of time; I think you get one to look great right now. We live in a disposable culture and everything is very now; the fact that you can go into a tattoo studio and come out an hour later wearing something of value is a sign of the times.

"It's hard to generalize with tattoos and tattooing, but overall we're in a good place—even people without tattoos are interested in it. I love the fact that it's all moving forward at the moment, and that's my job: To make people aware of what you can have. To let them know what's out there!"

For the latest info from the industry, check out www.skindeep.co.uk

Guy Aitchison on hybrid art

"I have combined tattooing with implants on a couple of clients, making for a very striking look. I gotta be honest, though: I am kind of a purist when it comes to tattooing. Part of me would rather try to create the look just using tattooing. I'm more excited by that challenge than I am about implants and more radical body sculpting, which for the most part is uncomfortable and at least vaguely impractical for the wearer." **(See page 72 for more Guy.)**

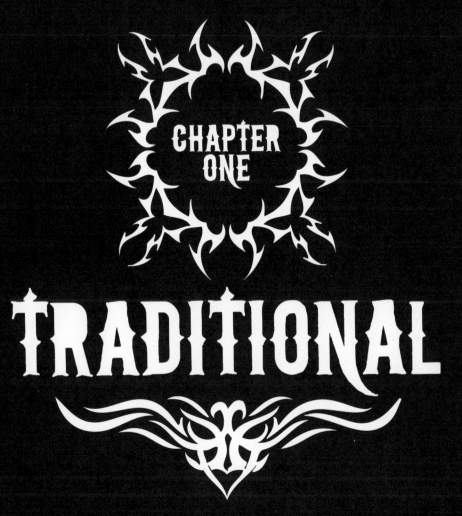

CHAPTER ONE

TRADITIONAL

They may be the elder statesmen (and women) of the tattoo
world, but traditional designs are anything but old-fashioned—
think skulls, dragons, mermaids, and much more.

OLD SCHOOL

Call it traditional, call it Americana, call it Old School—but whatever you call it, show it some respect. You don't weather more than a century of fashion storms without being hard as coffin nails.

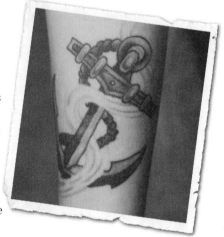

This page: Anchors, swallows, and hearts are classic Old School motifs. Facing page: Large-scale Old School images make for enduring tattoos.

Even if you know nothing about tattoos and this is the first book you've ever picked up on the subject (thanks, by the way), you'll know Old School tattoos. Whenever a cliché is uttered about tattoos, it's usually linked to Old School ink. The "gnarled old sailors with anchors on their arms" cliché? Those are Old School tats. Or the one with the bright red heart and the scroll underneath with "Mom" inscribed on it? Again, Old School ink. The version of the Old School (or traditional) style we know today really started to cement itself from the 1950s onward in America—but let's not get ahead of ourselves. There's a whole lot more before that.

TRADITIONAL TATTOOING

Far from being the calling card of villains and tearaways, traditional tattooing in the US and Europe in the nineteenth and early twentieth centuries seems to have had a broad appeal. Designs were worn by sailors and circus performers, but also by the gentry—Samuel O'Reilly, inventor of the tattoo machine in 1891, was known to make house calls to ink upper class folk reluctant to visit his studio.

Beginning the tidal wave of blue-armed sailors, traditional tattooing also flourished in ports around the world as mariners collected permanent souvenirs of their journeys. Soldiers were much the same, continuing a line that stretches back to the American Civil War and the remarkably neutral tattooist Martin Hildebrandt—who inked Union and Confederate alike (never let it be said that inkwork isn't democratic).

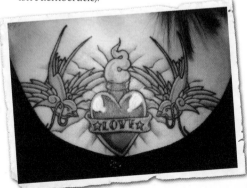

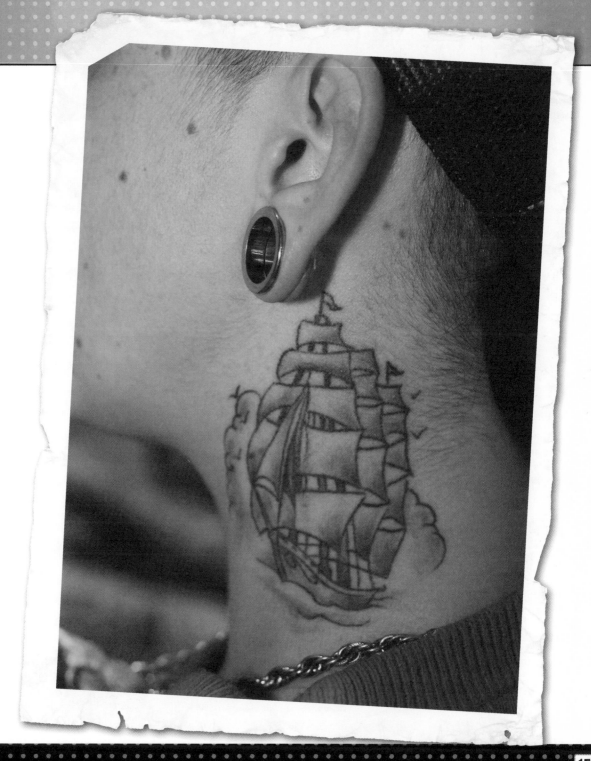

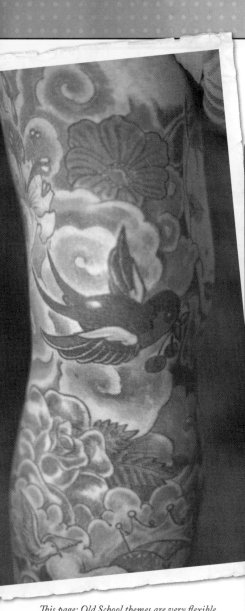

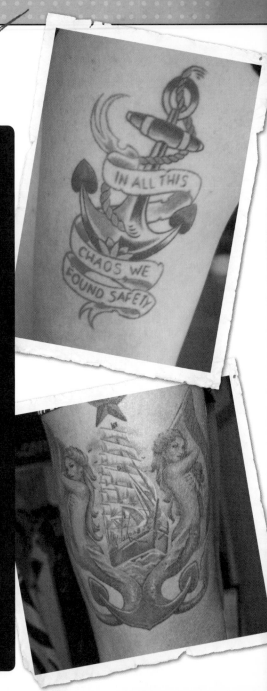

All at sea

SO WHAT DO THOSE SAILOR TATTOOS MEAN?

SWALLOW Seen as ships approach land, making this an obvious good luck image for sailors. A sailor would receive one after 5,000 nautical miles at sea, and another after 10,000.

ANCHOR Displaying sailor status, but also a steadying influence preventing the wearer from drifting.

TURTLE A sign that the wearer has crossed the equator.

SHIP A fully rigged ship showed the sailor had made it around Cape Horn.

ROPE A knotted rope showed a mariner had crossed the Equator, International Date Line, and Arctic and Antarctic Circles.

SHARK Jaws around? Need a bigger boat? A shark tattoo is designed to protect you from a toothy death if you go overboard.

This page: Old School themes are very flexible and can appear as intricate sleeves (above), simple icons (above right) or classic vignettes (right). Facing page: Art imitating life imitating art—Norman "Sailor Jerry" Collins, godfather of Old School tattooing. And rum.

TATTOOING AT WAR

As the century turned, the arrival of the electric tattoo machine—combined with more widespread tattoo flash—helped standardize how artists worked (and made tattoos more affordable for more people). Before then everything had been poked by hand, leaving plenty of room for error, variations in style and quality, and of course pain, but now a distinctive kind of "Americana" tattoo began to emerge from the US. These were the flag-and-heart tattoos with "Mom" written underneath, for example—worn by homesick G.I.s fighting around the world who wanted a reminder both of home and of what (or who) they were fighting for. Likewise, nautical tattoos had their own mythology, and more and more young men entering the forces were getting tattooed. This is the time some refer to as the "Golden Age" of tattooing, before it seemed to slip underground in the 60s and 70s, becoming associated with criminals and gang members.

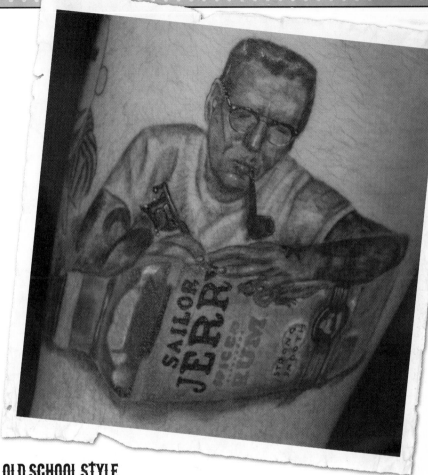

OLD SCHOOL STYLE

There was no single moment when the Old School tattooing style you see in modern studios popped into existence. Many important artists have contributed along the way—but arguably one of the most influential was Norman "Sailor Jerry" Collins. His work in the mid-twentieth century, and later the inking efforts of his famous protégée, Ed Hardy, helped develop the school: A simple color palette, bold lines, common themes, and a distinctive way of shading. He also borrowed techniques from Japanese tattooing that began to link designs together and create more unified pieces, moving away from the "stick it pretty much anywhere" approach, and producing designs with backgrounds and shading that appeared more balanced within the frame of the body.

COMMON OLD SCHOOL THEMES AND MEANINGS

So, back to where we started: Old School tattoos are the ones with anchors, hearts, swallows, daggers, and pinup girls. They've proved to be remarkably adaptable, originally worn by soldiers and sailors, but gleefully embraced by rock 'n' roll rebels, biker gangs, punks, and now ink collectors all over the world. And just as the designs themselves have weathered the storms of time, so have the meanings behind the most popular ones:

HEART Worn as a token of love and devotion (including devotion to your mother, of course), and as a memorial to departed loved ones.

DAGGER A token of death, violence, and stealthy, close-in fighting suggesting hidden danger; but also a protective symbol, badge of courage and warrior status, and of heartbreak when stabbing a heart (or swallow).

GAMBLING AND BOOZING Never too far away from the rebellious side of Old School (and people), alcohol, cards, and other vices crop up to show temptation. The tattoos can warn against sin and drink, or show that the wearer is likely to run toward them looking thirsty.

Lust, liquor, and general licentiousness are common themes in Old School inkwork, and nothing sums this up better than "Man's Ruin" (bottom right).

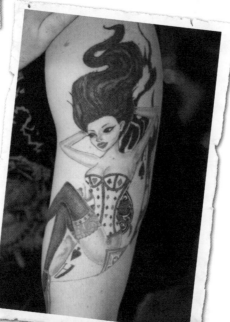

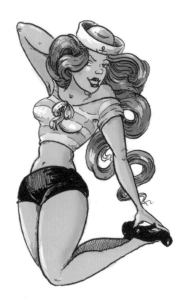

PINUP GIRL The original Bettie Page-inspired pinups were never going to win prizes at the "Female Empowerment" awards, but they've become classic designs for both sexes, embodying a cheeky sexuality.

SWALLOW Freedom and love, as well as nautical significance (see page 16).

These are just a few of the images that have endured and still appear in flash artwork and custom designs. Like a tough old sea dog with those blue anchors, Old School tattoos will probably still be sat out on the porch long after some new styles have had their moment in the sun and faded away.

All about the Old School

"Traditional tattooing comes with a proven track record; you know what you're getting from it. It's simple, understated, bold, and classic. It was made for tattooing: It's not something adapted to work within the limitations of tattooing, it's something designed to highlight the strengths.

"This style of tattooing is history in itself. The imagery is definitely something that reflects wars and military culture of the time alongside various social movements and key events. If you meet someone who got tattooed through certain wars and events, the tattoos act almost as a timeline. Then there's the obvious history of the tattoo machine, flash, and notable shops and figures. It's a rich culture and something that created a set of rules and guidelines that kept things pure and real.

"The designs have meaning and heart—they're designed to work on the skin before the canvas; it's tattooing at its finest. This is the imagery most associated with tattooing because it's tailor-made to tattoo, it's the essence of tattooing. I think the old 'if it's bold it'll hold' adage applies not just to skin but to minds, and that's why these images are still popular and relevant today."

Cian David Wright, Editor, Swallows & Daggers
swallowsndaggers.net

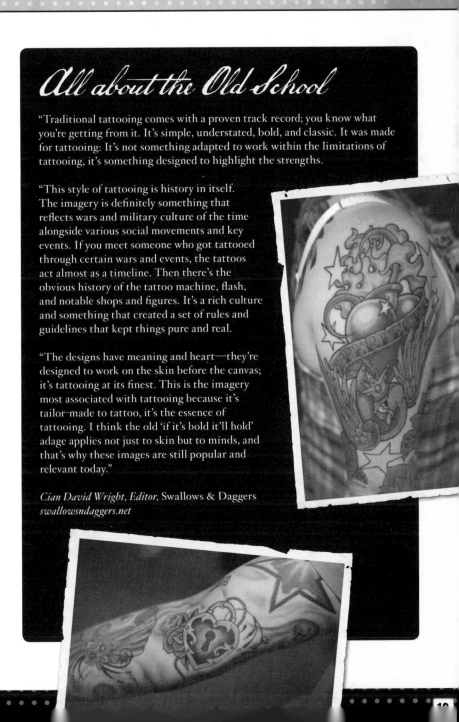

JAPANESE TATTOOING

Japan was busily evolving its unique style of tattooing for thousands of years before the rest of the world caught on. Japanese tattooing is steeped in traditions and lore—even the goldfish are sacred.

Japanese tattooing has had a long and eventful history lasting thousands of years. It's intimately bound up with the country's art and mythology, and has evolved a complex system of form and composition that makes it totally unique. The tattoos have a cast of characters, scenes, backdrops, and meanings that make them more like dramas played out across the skin, illustrating the wearer's personality

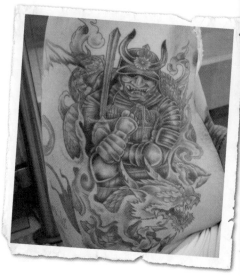

and life to date. A well-executed Japanese tattoo isn't something you just observe: It's there to be read, interpreted, and understood on many different levels, like a play or poem.

ANCESTORS AND OUTLAWS

As always with tattooing, it's difficult to pinpoint exactly when it began in Japan—estimates vary from 5000 to 300 BCE (a big timeframe by any standards). There's agreement on the form it took—lines and marks etched on the face, which have been seen on figurines recovered from tombs and are mentioned in Chinese accounts of Japanese culture, written around the third century BCE.

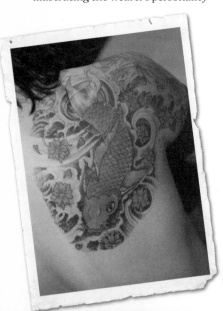

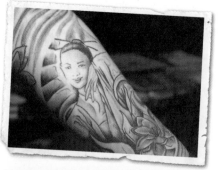

Over time these tattoos fell out of favor, perhaps due to Chinese influence, so much so that by the eighth century BCE tattooing was banned and handed out only as punishment to criminals. Those breaking the law would be forced to wear them as badges of shame and would be cast out from society. This continued well into the eighteenth century, to the extent that there were well-defined punitive tattoo designs: Crosses, lines, pictographs, and even symbols explaining what a person had done, and where.

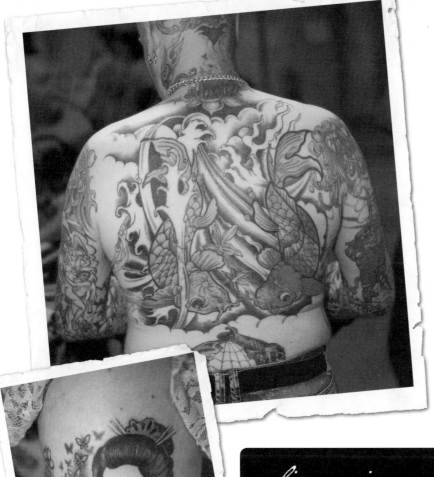

CRIMINAL INK

Toward the end of the eighteenth century—and coincidentally around the same time that Captain Cook was encountering tribal tattooing in Polynesia—the authorities stopped using tattoos as punishment. However, tattooing remained illegal until after the end of World War II in the late 1940s. Yakuza gangsters, though, were not interested in trifles such as legality, and wholeheartedly embraced tattooing, viewing their full bodysuits as proof of both courage and commitment to their gangs—because they were painful, and permanent. This association with the criminal underworld is lodged firmly in Japanese social consciousness, to the extent that those with large-scale tattoos are still not permitted into public bath houses to this day (although this is gradually changing).

Lip service

The Ainu people of Hokkaido, the most northerly of Japan's islands, had a rather different approach to tattooing. It was considered beautiful for women to have their lips and chins tattooed—the process involved much pricking with razor-sharp metal, followed by rubbing in birchwood ash. This dramatic form of permanent makeup sidestepped the tattooing ban and continued into the twentieth century before gradually dying out. (Maybe someone showed them lipstick.)

WOOD, FIRE, AND FOREIGNERS

As the Edo period (1600–1800) progressed, Japanese art and tattooing followed almost parallel paths. The woodblock prints of artists like Hokusai came to define the artistic style of the era, and combined with Kuniyoshi's illustrated version of the Chinese novel *Suikoden* gave tattooing the iconography it still has today. The artist imagined battles with scores of tattooed warriors, and populated his designs with mythical creatures, swirling water patterns, and flora and fauna all in perfect balance.

Happily for tattoo fans in the West, a convenient loophole in Japanese law meant that it was perfectly fine to tattoo foreigners despite the ban, so artists continued working and developing their skills in full sight of the law (and presumably sneaking gangsters in for clandestine ink sessions under cover of darkness).

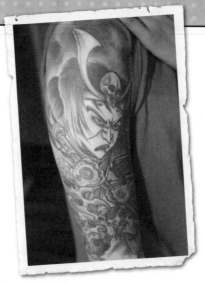

CREATING A JAPANESE TATTOO

Traditional Japanese tattoos ultimately form one giant piece (or "bodysuit") which develops over time, sometimes (although not always) starting at the legs and working its way up to cover the back, chest, and arms. The key lies in harmony: Representing the four seasons in the piece; ensuring the background composition is balanced; using people, animals, and mythical creatures in the right context and location; and generally creating something that sums up the person wearing it. This isn't something you knock out with a stencil and a biro in a few hours—it takes months, even years, of planning and development.

As you'd expect, true masters of the form study for years before committing needle to skin, and really know their stuff. They won't put spring and winter flowers next to each other, for example; or ink an animal that hibernates into a winter scene. The traditional method of tattooing involved hand poking the designs using needles mounted on bamboo; it's still used by masters today, although they might create the outline using a machine.

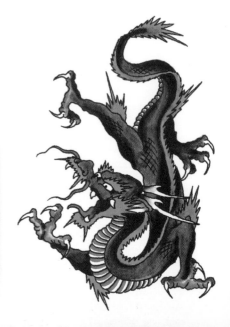

Hidden dragon

Tattooing has never been restricted to just sailors, bikers, and the alternative crowd. On a trip to Japan in 1882, a certain English gentleman named George visited the tattoo master Hori Chiyo and had a red and blue dragon inked on his arm. The dragon was to bear witness to interesting times: It was decorating the skin of the Duke of York, later King George V of England.

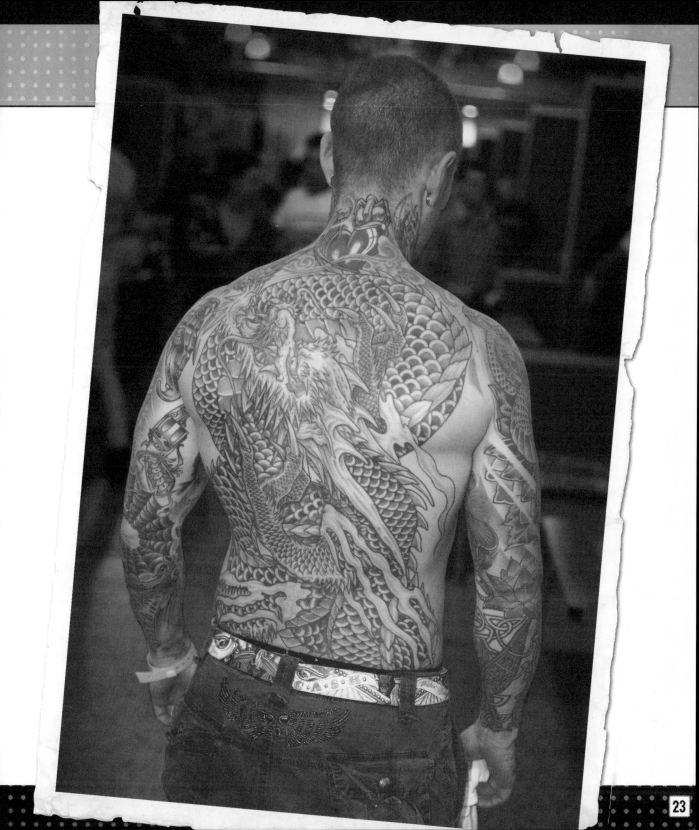

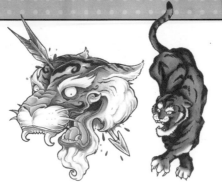

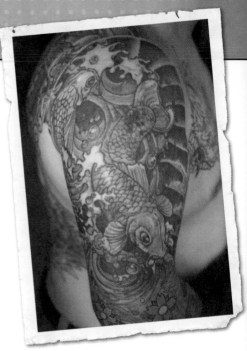

READING THE DESIGNS

Entire books are devoted to the symbolism of Japanese tattooing—it simply won't all fit into these little pages. But to give you an idea, here are some tigers and dragons and other magical things.

DRAGON A far cry from the flame-spitting versions in the West, dragons are spirits of air and water that bring good fortune. They signify imagination and spiritual attainment, protection, and the balance of power and grace. Dragons are usually surrounded by water and air, their spiritual environment, to show how they exist in balance with nature.

TIGER Symbols of luck, protection, and the warrior spirit, tigers are fearless, aggressive, and savage in combat. They're also the spiritual opposite of dragons and can represent our darker, violent side. When shown with dragons, their position indicates which side rules the wearer, or whether they believe they've achieved harmony. Yes, tigers are cool.

KOI What's a fancy goldfish doing in this list? Plenty. Leaping koi represent the ongoing obstacles the soul faces in life and the challenges that must be overcome. In Chinese mythology, the koi that jumped through the Dragon gate on the Yellow River was rewarded for its tenacity by becoming a dragon, the pinnacle of spiritual power: A pretty good ambition for anybody, hence its translation into Japanese tattooing.

FOO DOG Not dogs; they are actually inaccurate depictions of lions by artists who had never seen them. Foo dogs protect palaces, temples, and homes and are the Buddha's magical companions. Often shown in pairs, Foo dogs embody strength and nobility and will drive away evil like a (magical) mutt chasing the postman.

For a few more traditional designs, see the "Blooms and Leaves" chapter (page 36).

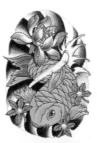

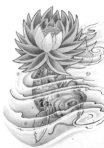

JAPANESE TATTOOS IN THE WEST

The Japanese style has influenced Western tattooing in many ways, not least of which is the insight Norman "Sailor Jerry" Collins gained into form, composition, and the importance of background thanks to his exposure to it. His ability to bring the Japanese aesthetic to American themes was a big step toward creating the Old School tattoos that have become so enduring. Before, designs were scattered all over the body. After, they were more unified and coherent, using background shading and negative space within the images themselves.

It's fair to say that a full Japanese bodysuit is a huge commitment however you look at it, so clearly not everyone in the West (or Japan for that matter) is going to seek out a total torso tattoo. Instead, people might isolate

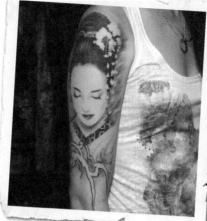

elements from the tattoos—leaping koi against a water background, for example—while still maintaining the style and symbolism of the Japanese tradition. This allows artists and wearers to experience and enjoy the tattooing, without the impact on time and flesh. But however far people choose to go, Japanese tattooing is an ancient practice that will doubtless continue long into the future.

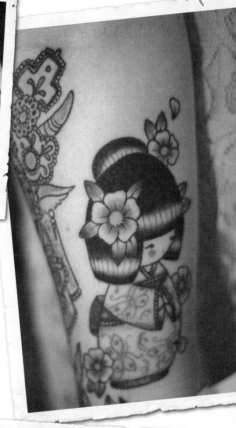

Underarm erotica

The full Japanese bodysuit can be full of surprises. Traditionally a channel of bare skin remains down the front of the torso, for example, so that the wearer can still wear an open-chested garment without their tattoos showing. Better than that, though, are kakushibori—"hidden tattoos"—positioned on the inside of the upper arm. As this area isn't usually seen unless the wearer wants you to see it, it's often the place for joke tattoos and erotic images of naughty naked folk. Who knew armpits could be sexy?

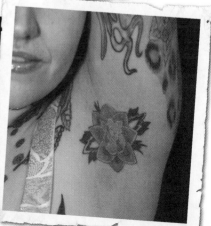

SEX AND LOVE AND ROCK 'N' ROLL

Whether or not you find a four-four beat and a bunch of inked skin wildly attractive, tattoos have been synonymous with doing the wild thing (in every sense) for decades.

Some pain, a lot of pleasure, pulling strange faces, and sometimes making incomprehensible choices you regret later? Yes, getting a tattoo and having sex have definitely got a few things in common. Naturally some people find inkwork about as sexy as eating a sun-rotted dead fish, but for others it's guaranteed to push all their buttons (including some they didn't know they had); and for some, the simple act of getting a tattoo is sexy. It's something they can keep between themselves and anyone they choose to be intimate with—the design doesn't even have to be overtly sexual in itself.

IMAGES OF LOVE

People being what they are though, tattooing has evolved plenty of designs that point to sex, love, and the bad behavior associated with it. So, for all the lovers out there, here are a few ink classics in the traditional style—the old ones always were the best.

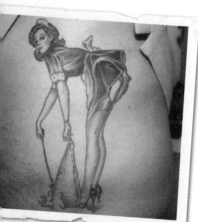

Here come the girls: Pinups can be naughty, flirtatious, or downright provocative, depending on the wearer, and have been tattoo staples for generations.

PINUP GIRL Based on Bettie Page, Marilyn Monroe, and various screen beauties, the original pinup-girl tattoos were the skin equivalent of pasting pages of *Playboy* into your locker. They were hugely popular with soldiers and sailors (curiously enough, groups of men who would be separated from women for long periods of time—coincidence?), to the extent that the Navy eventually passed laws to prevent those with "lewd" tattoos entering the service. Result? Tattooists spent much of the war inking more clothes onto semi-naked tattoos so that men could enlist.

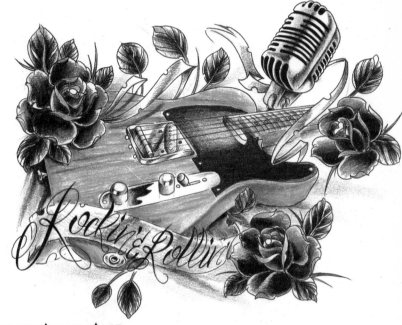

CUPID The Roman god of love was the son of Venus in classical mythology, and would wing his way around shooting arrows into mortals to make them fall for one another—not always in a good way. Tattoos often depict him as a cherub, armed with those pesky arrows, readying himself for sharp-pointed matchmaking—possibly suggesting the wearer is a fool for love, a good shot, or an easy target.

CHERRIES The door swings both ways with this little fruit. It can be a symbol of purity on one hand, suggesting virginity (sometimes referred to as a person's "cherry" in slang) and abstinence by its conspicuous presence on the wearer's skin. On the other hand, cherries are often inked in a suggestive way, dripping with sweet juices and looking plumply luscious—either as a sign that the fruit is ready for picking, or hinting that the wearer has had a taste and wants more. Cherry blossom is rather more spiritual—see "Blooms and Leaves" (page 36) for more.

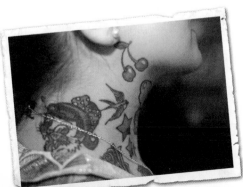

THE RHYTHM METHOD

The birth of rock 'n' roll in the 1940s and 1950s coincided with a change in the attitudes toward tattoos in the US and Europe. They gained a grimier reputation and began to be adopted by bikers, gangs, and anyone wanting to kick back at society. Rock 'n' roll went hand in hand with this, so classic rock 'n' roll images can hint at a rebellious streak, as well as acknowledging all the barely contained sexual energy of the music in the early days. (Great balls of fire, anyone?) Images can include 1950s-style guitars and microphones, figures of musicians, and even the odd musical note inked in the Old School fashion.

There are many other designs out there—hearts are probably self-explanatory as symbols of love, for example—and they can be rendered in many styles. The ones here are often seen in both custom work and tattoo flash and have proved they have staying power, but more importantly bring a bit of humor to the business of sex and love, which we all need from time to time. And rock 'n' roll? That's always going to be fun. All together now: You shake my nerves and you rattle my brain…

DEATH AND ALL HIS FRIENDS

Death-themed tattoos can certainly be all about the Big Sleep, but there's more to them than that. They can warn, commemorate, and even celebrate life—now smile at that skull!

Shakespeare's Hamlet muses on death as "the undiscovered country." Artists, writers, philosophers, and pretty much every human who ever lived has wrestled with the concept at some point. The American statesman Benjamin Franklin declared that only two things in life are certain: Death and taxes. But while the abstract economic principle of taxation has so far failed to excite tattoo artists, our mortal preoccupation with death has made it something of a tattooing mainstay.

for death is that of the Grim Reaper, a form he regularly assumes in tattoos— the hooded figure (often a skeleton) bearing a sickle or scythe imagines death as a being who harvests souls with his blade. In this incarnation tattoos can be inspired by the symbolic and serious or the light and humorous, embracing everything from death in fifteenth-century morality plays to the *Discworld* novels of Terry Pratchett.

DEATH IN PERSON

It's tough doing battle with an enemy you can't see, which might explain why death has been brought to life in many different guises throughout time, and tattoos. Death has appeared as a physical character in most of the major world religions, including Christianity, Islam, and Judaism, where he is variously an angel, a messenger, a vengeful spirit, and one of the four horsemen of the apocalypse, riding a white steed and accompanied by Hell. But perhaps the most common persona

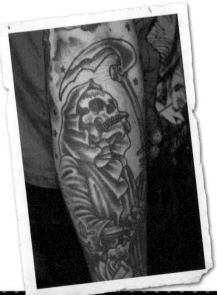

SKELETONS

Shrugging off the dark robes and appearing as naked as it's possible for humans to get, the bare bones of skeletons are clear representations of death in tattoos. They can provide a source of gloomy, morbid introspection, encouraging us to turn the lights off and listen to emo music played on a church organ; or it can urge us to seize life's opportunities, because our time here is brief and those bare bones are waiting.

That said, skeleton tattoos can also be scary as hell and operate on a much more intimidating level, appearing as the evil undead. In this guise they're more suggestive of horror than meditations on life and its passing, but to the nimble-minded tattoo-wearer they can easily be both.

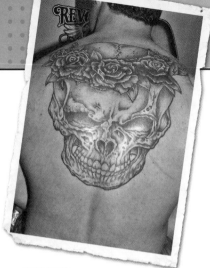

SKULLS

Reducing the skeleton down to a single piece, the skull is instantly recognizable as having once been human and is one of the most potent symbols of death. It's existed in many forms, from the Nazi death's head logo worn by the SS, to the international symbol for poison, and of course the Jolly Roger. For a reminder that death grins at all of us, you can't beat a skull tattoo: it's a tremendous leveler, reminding us that we're all the same underneath and will suffer the same fate.

Again, this could be taken in a "let's all run to the cemetery and jump in a hole" way, but skull tattoos can be also interpreted as positive things. Building on the classical concept of "memento mori" ("remember you will die") they highlight the value of the living present, the still-warm flesh they're inked on, and serve as constant prompts to embrace life. A skull can even be seen as a lucky talisman in some circles (such as biker gangs), allowing the wearer to cheat death; pictured with a snake coiled around it the image also suggests immortality.

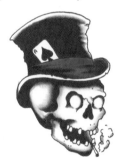

Of course, brandishing a freshly stripped skull over your head and bellowing at your enemies isn't necessarily a life-affirming experience for them, and skulls have certainly fulfilled negative functions throughout history. Wearing them as trophies was a practice adopted by warriors from several tribes and intended to intimidate their foes; in today's world tattoos can serve a similar purpose in sport, which may explain their popularity among boxers, wrestlers, martial artists, and other contact-orientated competitors. Nothing says "I'm going to knock you out in the first round and tapdance on your head" like a tattoo of a leering skull wriggling with maggots. On fire.

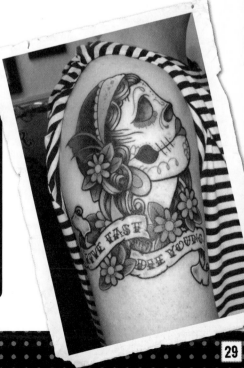

Memorial tattoos

While many tattoos can be focused on coming to terms with our own inevitable demise, some are designed to remember those who have gone on ahead. Memorial tattoos can come in many forms, but there are some classic versions, often in the traditional or neo-traditional style—headstones, roses, weeping angels, and scrolls bearing the names of the departed are common themes. Another approach is to use objects that were important to the person in life, or perhaps a birthstone or zodiac sign; all intended to celebrate a life well-lived rather than simply mourn its end. ·

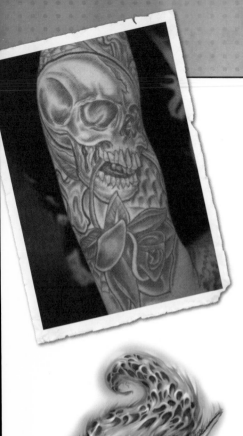

DEATH, WHERE IS THY STING?

Skeletons and skulls aside, there are many other popular tattoo images that either obliquely reference death, or hint at rebirth and resurrection. Playing cards such as the Ace of Spades or the death figure in the tarot are common symbols, as is the "snake eyes" dice combination of twin ones; even jaguars, owls, and black cats are harbingers of death in some cultures and fulfill the same role in tattoo iconography. None of these images has to explicitly signal the doom of the individual: They might mark the "death" of one stage of person's life and a fresh start, for example.

Edging slightly closer to eternity, mythical creatures like the phoenix are popular tattoo images. According to legend the phoenix is immortal, living a fixed number of years before bursting into flames and being reborn from its own ashes—the bird can symbolize regeneration and passing from one part of life to another, as well as the unending cycle of existence. It's joined in this by the humble scarab beetle, which to the Egyptians symbolized death and rebirth to such an extent that scarab tokens were often buried with the dead to help them pass into the next world—sort of an "access all areas" backstage pass to the afterlife.

For anyone wanting a permanent reminder of mortality, there are many tattoos that fit the bill—but not always in a depressing way. Instead, they can be positive, life-affirming, and even celebratory: Death is indeed the undiscovered country, as the bard put it, but that doesn't mean we can't prepare for the trip with a light heart.

Day of the Dead skulls

A very popular traditional / neo-traditional tattoo image, these colorful motifs are inspired by the sugar skulls used during the Mexican Day of the Dead festival on November 2. Nothing to do with zombies, the festival celebrates the lives of deceased friends and family and involves much drinking, dancing, eating, and storytelling based around the lives of the departed. The sugar skull offerings (and tattoos) point to death and rebirth, but also encourage the spirits of the dead to return to the land of the living to spend time with their loved ones; they can even bring good luck.

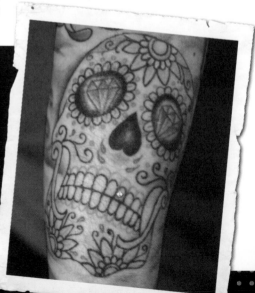

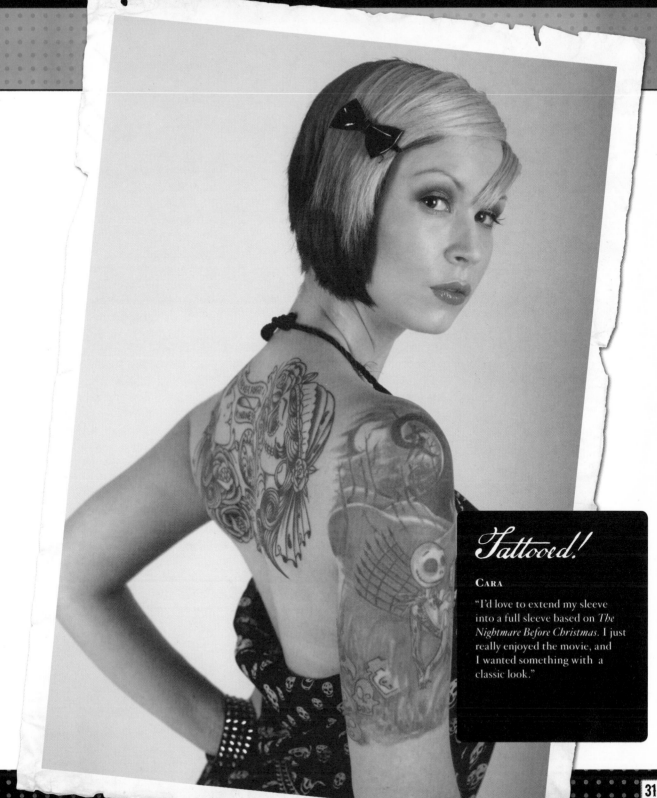

Tattooed!

CARA

"I'd love to extend my sleeve into a full sleeve based on *The Nightmare Before Christmas*. I just really enjoyed the movie, and I wanted something with a classic look."

WILD THINGS

Ah nature: Sharp teeth, razor claws, venomous fangs, assorted hairy bits. Or is it gorgeous colors, beautiful plumes, and outstretched wings? Either way, it's great for tattoos.

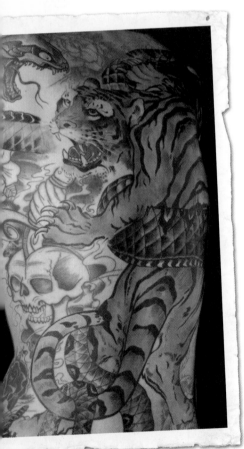

The natural world and the beasts living in it have inspired people to create art since we first daubed animals on cave walls. Since then the designs have become more sophisticated and carry more complex meanings than the original "stick a spear in one of these or we're all going to starve" images—animal and nature tattoos can hint at a person's character, heritage, and even their faith.

BIG CATS AND LITTLE KITTIES

The lion is regarded as king of the beasts in Western culture and many of its meanings as a tattoo spring from this. Lions symbolize strength, leadership, nobility, and courage, and are associated with Christ, Buddha, and the Hindu god Krishna, making them appropriate choices for followers of those faiths. Lions also feature in rite-of-passage myths in Africa, were seen as warrior spirits in Egypt, and are considered lucky in China and the Far East (unless you're an antelope).

Slugging it out with them for the honor of top cat are tigers, revered in the East (see Japanese tattooing for more on the striped ones), and generally viewed as embodying ferocity, guile, and possessing a fearsome beauty. Although try telling that to Winnie the Pooh and Eeyore.

Not to be outdone, jaguars content themselves with being the symbol of death and the underworld in some South American myths. They were also seen as spirit guides, giving them a mystical quality on a par with the snow leopard—an enigmatic, solitary hunter in the Himalayas that might point to the Buddhist beliefs associated with that region. "Regular" leopards—as opposed to the diet ones—were thought to bring protection from evil in ancient Egypt, and as for the panther… jet black, prowling, lithe, and supple? That'll be a symbol of night and mysterious sensuality, then.

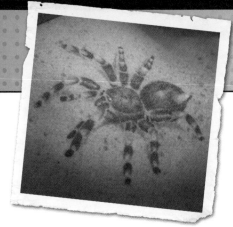

Spiders may be small but they can pack a fierce bite, which gives them something in common with scorpions. These armor-plated arthropods can kill, making them feisty tattoos suggesting toughness and a personality that has a sting in the tail; but they're also used as good luck charms and as a defense against evil.

The humble housecat still rates highly on the tattoo meter, too—black cats variously bring luck or ill omens depending on the superstition you prefer, and also have links to witchcraft. Notoriously fickle animals, cats in tattoo form might suit those who recognize they have a changeable personality. Or who cough up hairballs from time to time.

CREEPY CRAWLIES

If you've ever looked at insects through a magnifying glass, you'd be forgiven for thinking that aliens walked among us. Insect tattoos—especially oversized ones—can revel in the spectacular weirdness of nature and make for intriguing body art, but there are a few critters with some ancient symbolism attached to them.

Spiders, for example, can signify artistic skill, agility, and even perseverance (have you ever tried knitting? Imagine building a web), while web tattoos themselves can be nicely Gothic, point to the sense of feeling trapped, or be a popular choice for prisoners—illustrating their incarceration.

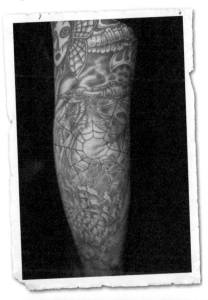

Scarab beetles were important to the ancient Egyptians. Their habit of rolling balls of dirt was interpreted as reflecting the sun's journey across the sky and by extension death and rebirth, just as the sun dies and is resurrected at the horizon each day. No self-respecting mummy would be seen dead without a scarab to help them into the afterlife.

Forces of nature

The world itself can be as much a part of tattooing as the creatures who walk on it. The oceans and mountains can represent the awesome creative and destructive powers of the planet (and mountains have been pretty essential to religions—Moses met God at the top of one and Buddhism owes much of its heritage to the high places of the world), as can clouds, storms, lightning, and rivers—often seen in Japanese tattooing.

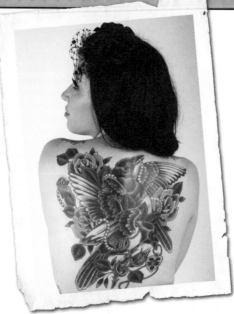

And as for squirrels, well, they're not common tattoos. But feel free to invent your own snack/sexual symbolism around the finding, hiding, or eating of nuts. (Sorry.)

REACH FOR THE SKIES

Of all the birds depicted in tattoos, the eagle has possibly the strongest claim to ruling the roost. It's long been a patriotic symbol in Old School Americana tattoos, but isn't exclusively the property of Uncle Sam. Eagles can suggest power, soaring freedom, the liberty of the imagination, strength, clear-sightedness—and they're also linked to John the Baptist, the Hindu God Vishnu, and the sun (in Native American folklore).

IN THE DEEP DARK WOODS

A few inhabitants of the forests make regular appearances in tattoo art. In particular, wolves are complex symbols with both positive and negative aspects throughout European and Native American folklore, which sees them variously as cunning and ferocious hunters, spirit guides, loyal pack animals, and even the devil, the sheep-slaying antithesis of Christ the shepherd.

Sharing the woods, bears have been regarded by numerous cultures as emblems of great strength and protective ferocity (she-bears defending cubs); their hibernation is also symbolic, pointing to a gradual awakening of the subconscious or enlightenment gained after a long period in the darkness.

Slither!

Snakes are important to tattooing for a number of reasons. For a start they're flexible images that can suggest Satan, immortality, renewal (thanks to their skin-shedding antics), danger, phallic symbolism, and even creation or spiritual protection according to Norse, Aboriginal, and Buddhist traditions. Plus, they're adaptable creatures perfectly suited to mapping out the muscles, curves, and contours of the human body in ink, which has doubtless helped make them such a popular choice. Just don't take any fruit from them. You never know.

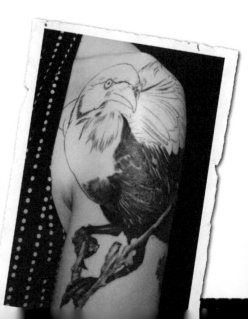

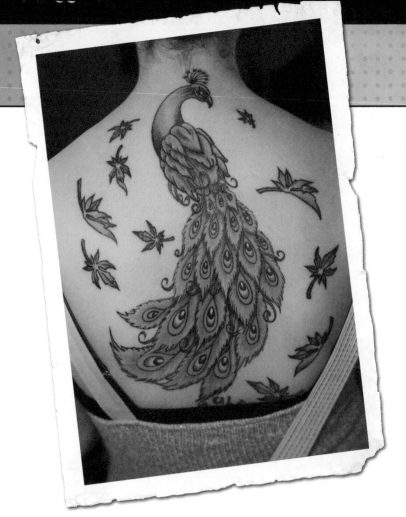

BUTTERFLIES

Their transition from lumpy caterpillar to winged jewel makes the butterfly a handy symbol of transformation, which could be spiritual, physical, or philosophical. Butterflies can point to changing phases in life, or be allegorical insects hinting at resurrection, and a surprising amount more: The transfigured final breath of life to the Aztecs, the soul's fragility to the ancient Greeks, and the spirit of fallen samurai to the Japanese. Plus, they're rather pretty.

From delicate butterflies to toothy tigers, the natural world provides infinite inspiration for tattoos all over the world, and in every imaginable kind of style. They can be chosen just because someone likes them, because of their religious or mythological meaning, or as a lucky totem—and happily, you'll run out of skin space before you run out of insect models.

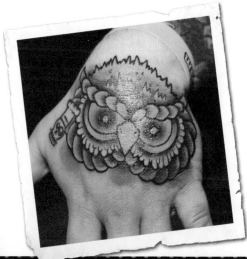

Meanwhile, owls are busily symbolizing wisdom for many people. However they're not limited to that, and have suggested death and black magic to Native and South American peoples, and can bring an unsettling feel to tattoo art thanks to associations with their spooky nighttime calls and silent hunting.

Want more birds? Check out the "Old School" chapter (page 16) for the story behind swallows.

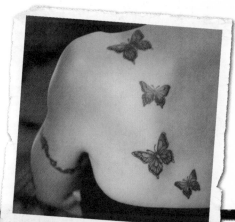

BLOOMS AND LEAVES

Fragile blossoms, mystical lotus blooms, blood-red roses with sharp thorns, Gothic ivy trails: Flowers and vines are infinitely varied and can be full of surprises. And they're not just for girls.

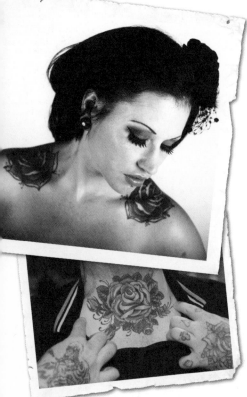

Flowers can appear as standalone tattoo images (this page), or form the backdrop for other subjects to add depth to the composition (facing page).

You don't need a reason to buy flowers or have them in your home and garden—they're beautiful and just nice to have around. The same is true for tattoos of flowers, vines, trees, and anything vaguely leafy: They can simply be there to add color and beauty to the skin, either as part of the background for a larger piece, or as standalone designs in their own right. Plus, as long as you get the aftercare right, your blooms aren't going to wither up and die if you don't tend to them enough.

FLOWER POWER

On the other hand, if you've got a deeper message and want to say it with flowers, there are a couple of very hardy specimens that have served tattoo artists and collectors well over the years.

ROSE Let's start with love. It's what roses do best: Act as a token of love in all its forms, from romantic love, to family love, to "I forgot [important date X] again, please forgive me" love. Tattoos of roses serve the same function and can

show that a person has a romantic soul; that their heart is spoken for; or that they're remembering someone with love. Love's not always, um, a bed of roses either—so some designs include the thorns to remind us of the potential for being hurt.

Roses can also be spiritual, and were sacred to Aphrodite and Venus, the Greek and Roman goddesses of love. Red roses are important to Christians as the bloom represents the blood of Christ, spilled to save mankind, and as a consequence God's love for humanity; they also contain a reference to the crown of thorns Jesus wore on the cross.

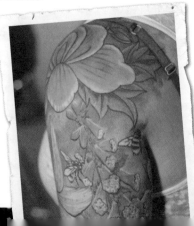

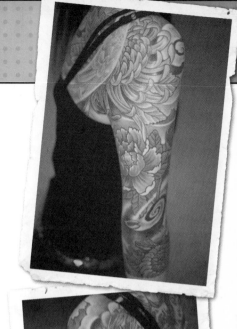

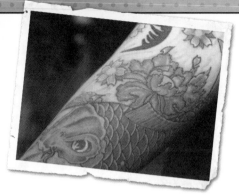

WINDING AND CLIMBING

Tattoos of ivy and vines are great as they can wind their way around the body and follow an individual's shape. If you're looking to go a little deeper, ivy's growth toward heaven could point to a spiritual quest, but more frequently acts a symbol of everlasting life and resurrection (particularly to Christians and Pagans). Grapevines have divine links to Bacchus, the Roman god of wine—or to anyone who likes to pray to the spirit of Shiraz—and it helps to mix a little ivy in there too, as the Romans believed it soothed hangovers.

(Note: The publishers accept no responsibility for the failure of your ivy tattoo to prevent your destruction by absinthe.)

LOTUS These flowers crop up in classical mythology as flowers inducing forgetfulness and indulgence, but the lotus is used far more regularly as a token of either general spirituality, or to signify a specific faith. The flowers are sacred to Hindus as they float on top of water (itself sacred) and point to the birth of Brahma—who appeared from a lotus bloom in Vishnu's navel; while to Buddhists they're a central part of their beliefs, representing pure Buddha-nature and referenced in the mantra "Om Mani Padme Hum"—"Hail to the Jewel in the Lotus."

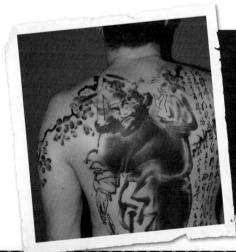

Sakura—the cherry blossom

Symbols of spring and renewal, cherry blossoms are an essential element in Japanese tattooing. Their beauty is always short-lived and reflects the swift life of the human soul, flowering briefly and suddenly gone—making them a metaphor for the perfect samurai warrior, living proudly in the beauty of the moment and ready to accept death in an instant. This meaning stretches through into Buddhism, where cherry blossoms signal life's impermanence and remind us to be awake, living in the present and not distracted by the past or future.

HEAVENS ABOVE

Like our ancestors, we look up to the skies. It might be to feel the sun on our faces or to howl at the moon (whatever turns you on), but the handy side-effect is finding some timeless tattoo designs.

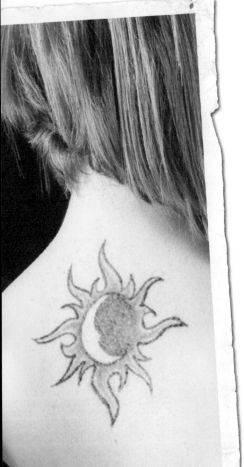

We look to the heavens for guidance, navigation, light. We even roll our eyes skyward when inspiration eludes us. Little wonder the celestial bodies we see up there—sun, moon, and stars—have such a significant presence in tattoo art.

BRING ME SUNSHINE

It might be lightly toasting beach bums the world over, fueling solar cells, or making gardens grow—whatever role it's playing, the sun is an overwhelmingly positive symbol of life, light, and warmth and this is reflected in tattoos. Rather than attempting to capture a pangalactic nuclear reaction in a realistic style though, artists depict the sun in a range of ways—you'll see tribal suns, traditional and new-school representations, stylized blackwork versions… it's a pretty universal subject.

Celestial tattoo designs can appear in any style and work well all over the body.

The sun has a powerful connection to the natural world and all things that grow, from algae to zebras, so it's obviously a potent symbol of the life force in all things. Taking this a little further, our nearest star becomes a significant religious emblem: The light it brings into a dark cosmos can be equated with the triumph of knowledge over the shadow of ignorance, or good overcoming evil. Its reappearance (or resurrection) at the start of each day provides even more explicit links with the divine, so a sun tattoo could symbolize Jesus; the light of God in the world; Buddhist beliefs in reincarnation and enlightenment; and any number of solar deities from ancient Egypt to the Incas.

Finally, as a symbol of light, sun tattoos can provide moral direction to wearers (reminding them to steer away from the shadows) and drive away any demons that might be pursuing them. And of course the sun gives Superman his powers. What more could you ask for?

FLY ME TO THE MOON

Apollo 11 astronaut, Buzz Aldrin, stood on the moon and described what he saw as "magnificent desolation," a contradictory phrase that neatly sums up the sense of both beauty and terror our satellite inspires in us.

For example, while we're all known to go crazy for a bit of sunshine, at one point the moon was genuinely believed to drive people mad—hence the word "lunatic," derived from "lunar," which describes anything to do with the moon. The moon is arguably a little more ambiguous as a tattoo design than the sun, carrying both positive and negative meanings—its inevitable links with the night (in which things can and do go bump) have linked it to witchcraft, evil, and sorcery—as if creating madmen and women weren't enough.

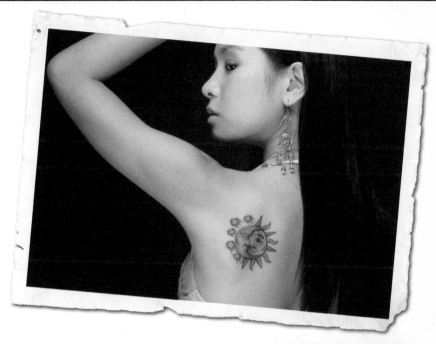

That said, the moon is also closely associated with light in darkness in much the same way as the sun, and can be a reassuring symbol offering a guiding light, both in real darkness and in the gloom of ignorance or evil. It can also be a sign of femininity (its effects on the tides of the oceans connecting it to the female menstrual cycle, another natural rhythm) and by extension goddess worship. It was linked to the Egyptian goddess Isis and the Roman deity Diana, but isn't exclusively reserved for the girls: The moon was a masculine deity in Aztec culture. And as numerous films and songs will attest, while the full moon can be a magnet for those nagging werewolves, it can also cast light over romantic ambitions.

Cover it up!

TOP TATTOO MAINTENANCE TIP:
However much you might like to worship the sun, your tattoos don't feel the same way. New ink in particular should be kept out of direct sunlight, as those rays are guaranteed to make it fade quickly. Yes, even sun tattoos—oh, the irony.

STARLIGHT, STAR BRIGHT

Sticking with the musical theme, stars are touted as something to reach for (or wish upon) in countless pop songs, nursery rhymes, and Disney tunes. Their light and aspirational symbolism has made them popular tattoo designs, and there are many different versions to choose from.

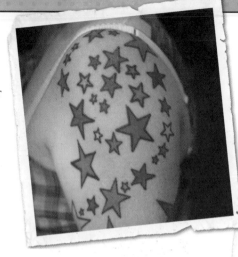

The simplest geometric star shape can appear in isolation or as part of a stream of stars, and can be purely decorative or symbolize magic, heavenly guidance, a goal that someone is striving to reach, or the light of inspiration. A more traditional version, the nautical star, is worn by sailors and represents the compass points, as well as a more symbolic meaning of finding your way in the world, while a star of David can signify Jewish faith or heritage.

Add to this the meanings attributed to star signs in astrology and the classical notion of benevolent spirits being placed in the heavens to watch over mortals as stars, and it's hardly surprising so many people choose to wear star tattoos. Combined with sun and moon, there's potentially a tattoo design for everyone—spiritual, secular, or both—in the skies at night.

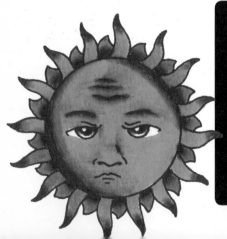

All together now

The sun and moon are often paired together in tattoo designs, allowing their meanings to combine into a balanced whole. This creates a symbol in which opposing but complementary forces exist in harmony—light/dark, positive/negative, male/female. Much like the Chinese concept of yin and yang, sun and moon designs acknowledge the complexity of the cosmic order and the interdependence of all things.

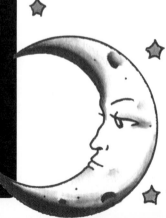

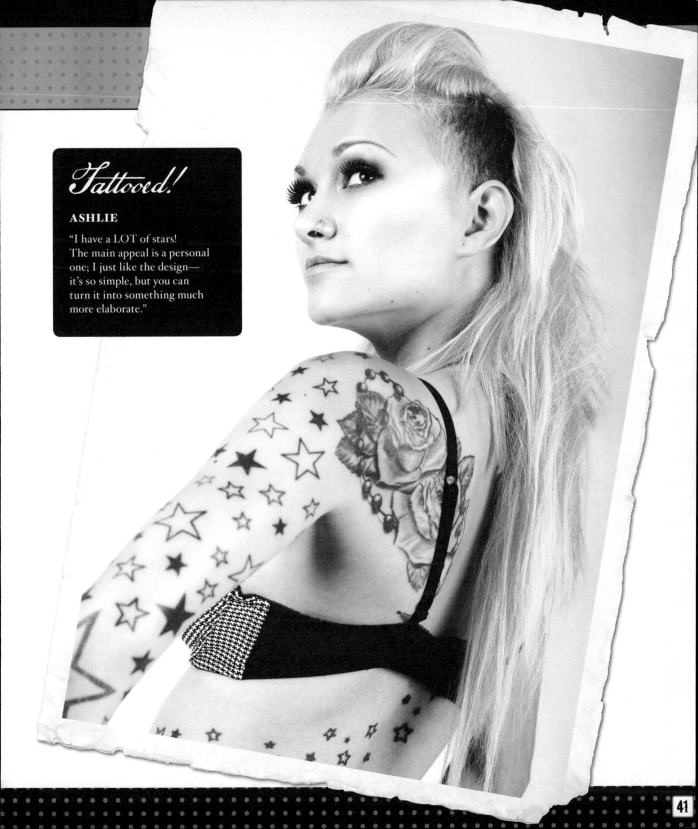

Tattooed!

ASHLIE

"I have a LOT of stars! The main appeal is a personal one; I just like the design— it's so simple, but you can turn it into something much more elaborate."

MAGIC AND MISCHIEF

There's no guarantee that getting a tattoo will put a spell on you, no matter how pointy of hat the artist. But if you're looking for some spellbinding images with added darkness, start here.

Magic can mean many things. It could refer to the old-fashioned conjurer sort of magic, with bunnies and hats and wands and suchlike; it could point to the world of fantasy with warlocks, witches, and wizards flinging spells at one another; or it could even mean the childlike version of magic we all embrace when we're young, full of fairies and magical beasts. Whether it's born of escapism or a deeply held belief in some form of magical lore, magic tattoos in all styles are popular with collectors.

BLACK MAGIC WOMAN

Starting with witches and witchcraft, magic can have a few different interpretations. In the Dark Ages, witches were seen as the consorts of the devil and were generally reviled, and over time their presence in fairy tales, folklore, and drama has often been a malign one. However, the witch can also be a symbol of female dominance, strength, and liberated sexuality—so as tattoos they can either be scary old crones or totems of feminine power, depending on the effect the wearer wants to achieve.

Moving into the modern era, witchcraft has become more closely aligned with the power of nature, and is a much more positive force. Modern adherents to Wicca (and similar belief systems) meet to commune with nature and worship goddesses, rather than carousing with demons and nasties, so tattoos reflecting this are a long way from bubbling cauldrons and frogs' eyes.

Although mainly seen adorning women, witch tattoos are suitable for both sexes as they can also imply any kind of spell-casting, and suggest that someone has been bewitched. Or that they're not in Kansas any more.

WIZARDS

The appearance of wizards throughout fantasy literature and in the movies seems to owe a debt to Norse mythology, where the god Odin is described in some incarnations as an old man with a gray beard, staff, and pointed hat, wandering the world. As this description is pretty much identical to Tolkien's Gandalf in *The Lord of the Rings*, it's easy to see how the comparisons might have arisen.

Left: Wizards can be based on fictional characters like Tolkien's Gandalf, as seen here portrayed by Sir Ian McKellan. Facing page: Fairies can take on many forms, from traditional folklore to something a little friskier.

AWAY WITH THE FAIRIES

If wizards can seem a little schoolmasterly, in charge of a stern kind of magic, fairies are the troublesome kids behind the bikesheds getting up to no good. They lead people astray, play tricks, cast spells, and generally get up to mischief, making them fun tattoos for those who like their magic to be a little more lighthearted. Much like children, fairies can be good as well as naughty sometimes, so they can also point to an innocent appreciation of the world around us—but just as Tinkerbell was a nuisance and the good fairy in pantomimes always has a wicked streak, they're never too far away from wreaking some kind of mild havoc.

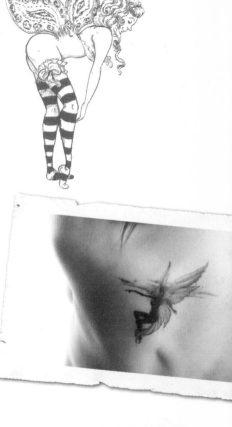

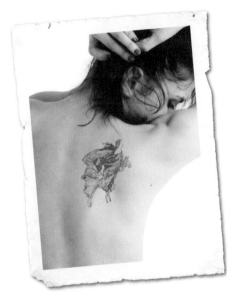

Whether or not latter-day wizards have purloined their looks and wardrobes from Norse mythology, their symbolism in tattoos refers either to power attained by learning and study, or through nature. They're generally positive characters who may act as mentors and guides, but there's the potential for some ambiguity with wizards—they must choose how to wield the power they've attained, so a wizard tattoo might be a wider comment on strength, learning, and how the wearer intends to use it in their life. The jury's still out on exactly what a Harry Potter tattoo means, beyond extreme fandom.

Practical magic

Certain tattoos can go way beyond symbolic powers in the eyes of those who wear them. Some soldiers in the Thai army will wear traditional tattoos that are hand-poked by Buddhist monks—it's a painful process involving needle-tipped bamboo poles, carried out while an apprentice chants prayers. This might seem extreme, but the end result is believed to be worth it: The magical tattoo makes you bulletproof.

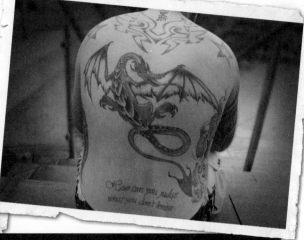

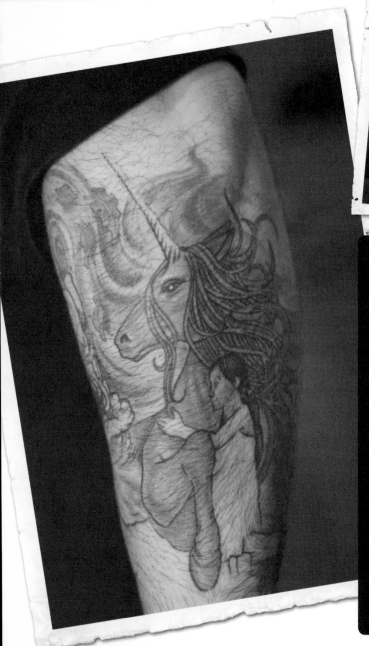

Magical beasts

Although many creatures step out of folklore and into tattoos, these two seem to be winning in the popularity stakes.

DRAGON Different to their Eastern counterparts (see the Japanese tattooing section for more on them), Western dragons are beasts of fire, not air or water. Often viewed as terrible or wrathful, spitting flames and guarding hordes of gold, this kind of dragon is one for fans of the fantasy genre and for those who want a symbol of supernatural power. Dragons in the West can also appear in religious iconography, where their defeat at the hands of archangels or saints symbolizes the triumph of good over evil.

UNICORN The horned horse is a sign of purity and good luck in various cultures, from medieval tales where it could only be tamed by a virgin, to Chinese beliefs in which the creature is lucky and will purify poisoned water. Tattoos could encourage the wearer to live a chaste life and to be virtuous, or might appear as a symbol of protection against bad luck and evil.

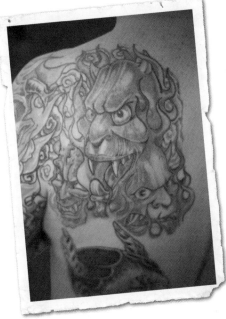

AND FOR MY NEXT TRICK

Finally, a magical tattoo could be inspired by the trappings of sideshow illusionists. Top hats, wands, and playing cards might point to showmanship and entertainment, but can go beyond that. Magic at its core is all about mystery, and is used to describe actions that can't be explained—a magical tattoo could acknowledge that things are not always what they seem in the world, or that the wearer shouldn't be taken at face value. They could have anything up their sleeve.

BETTER THE DEVILS YOU KNOW

For winged havoc of a different kind, you can always rely on devils. In this context we're not talking about the biblical devil—fallen angel and scourge of the faithful—we're referring to the cherubic mischief-makers in traditional-style tattooing. Sometimes referred to as "Hot Stuff" after a cartoon incarnation in the early twentieth century, these characters signal that the wearer might be prone to one or two vices, might have a wicked sense of humor, and probably doesn't take life too seriously. A long way from evil, they're tattoos for the irreverent souls among us, rather than the ones with a suite pre-booked next to the eternal lake of fire. (Devil girls serve a similar function, but with an added dash of hot sauce.)

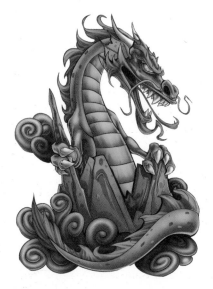

Top left: Tattoos inspired by Japanese Oni masks are very popular. The Oni are wicked mythical demons, but their use as masks in festivals (and tattoos) is intended to drive away evil and bring good fortune to the wearer.

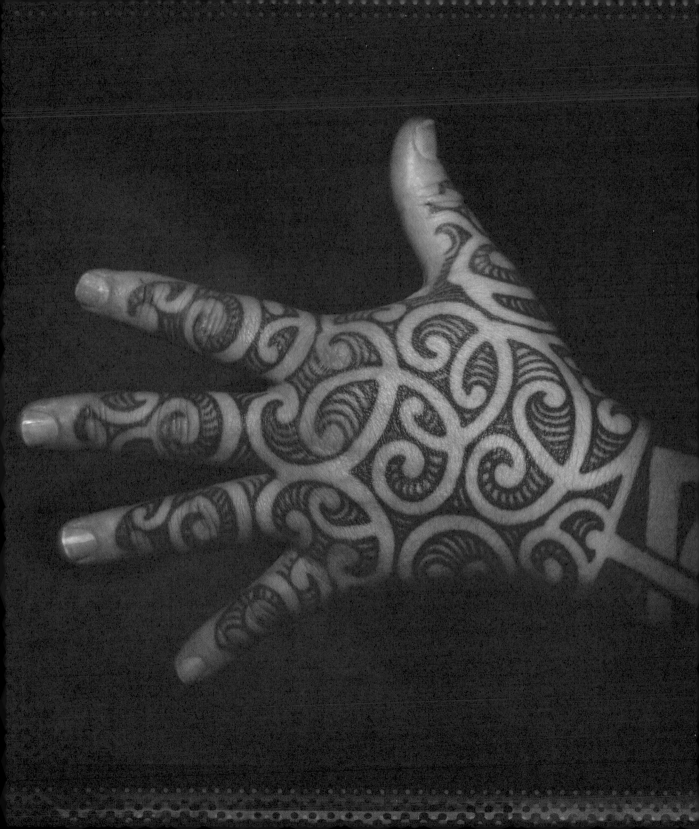

CHAPTER TWO

FLAT LINE

Tribal designs, symbols, text… these tattoos use a bold
approach to get their message across, whether it's a token of
faith, a sign of national identity, or a favorite quote.

TRIBALISM

Bold, striking, and even a little intimidating, tribal tattoos might seem to be all surface. Far from it: Tribal art is full of meaning and plays a vital part in the tale of tattoos throughout history.

The world of tattooing as we know it today owes a lot to ancient tribal tattoo practices, particularly those found in the Polynesian islands. It was here—Tahiti, specifically—that Captain James Cook landed in the eighteenth century and discovered a flourishing tattooing culture, which his crew were quick to embrace. As there were no gift stores around, what better form of souvenir for men who traditionally had few possessions than a tattoo from the land they'd found at the far end of the world? Tribal tattooing has gone on to become one of the most popular and influential styles around.

WHY TATTOO?

One of the striking things Cook and other observers noted about Polynesian tattooing was that it formed an important part of the-rites and rituals of the societies that carried it out. Tribal tattooing served (and still serves) many purposes, both practical and spiritual. For Samoans, the traditional pe'a tattoo was a rite of passage into adulthood for young men, before which they were not considered mature and couldn't speak in the presence of adults; in Tonga it was a vital aspect of warrior culture and showed status; while to the Maori it showed a wearer's position within society.

Indeed, tattooing was so important that the artists themselves were regarded with a great deal of reverence—not surprising in the case of the Dayak people of Borneo, whose tattoos were believed to light up after death and guide them through the underworld murk and toward the village of their ancestors. (No amount of UV ink will serve this purpose, by the way, whatever the guy in the backstreet studio tells you.)

TRIBAL TATTOO MEANINGS

The geometric symbols, shapes taken from nature, solid black patches, and other features of traditional tribal tattoos are far from random—another reason artists were held in such regard was that a great deal of skill and knowledge was required to execute a meaningful tattoo.

These meanings are highly complex, but most are linked to the cultural heritage of the tribe and the wearer's place within it. The Maori ta moko tattoos inscribed on the bodies and faces of the indigenous people of New Zealand told of the wearer's lineage, or whakapapa, and were a source of considerable pride (as they still are among the Maori who choose to wear them). For the Samoans they were a badge of identity and created a sense of community that they still carry for many, wherever they are in the world. For the Dayak people they had a further meaning outside of the spiritual world: They pointed to the number of heads a warrior had taken—though this is one tradition that hasn't quite caught on in the twenty-first century.

Tribal art is designed to follow and emphasize the contours of the body (left and right).

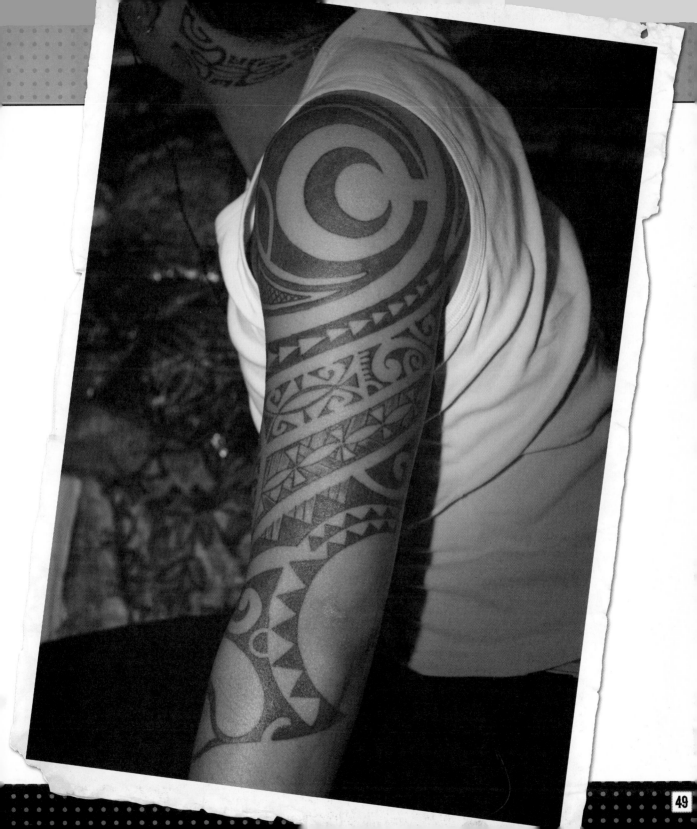

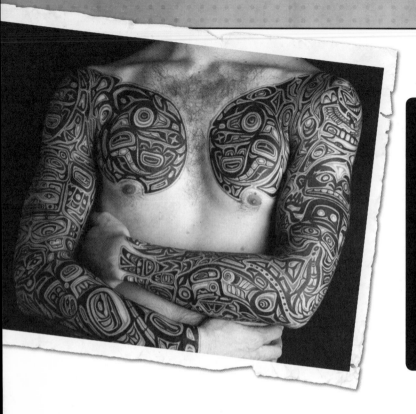

Haida tattooing

The Haida tribe of the Pacific Northwest of America boasted a killer color scheme that the White Stripes would die for: Red, white, and black. Their distinctive artwork was inspired by their totem animals and included the raven—a merry trickster who brought hunting and fishing to mankind; the eagle—who carried the same associations with freedom as he did elsewhere; and the orca—the most powerful creature in the oceans. Bears, frogs, and the storm-bringing Thunderbird also featured.

METHODS AND PLACEMENT OF TRIBAL TATTOOS

It almost goes without saying that any tattoos conferring adulthood, high status, or passage to the afterlife don't just get drawn on in crayon and with kisses from mermaids. Traditional tribal tattooing methods are painful, bloody, and (back in the day) could last days, weeks, or even months, depending on the tribe.

In the "just kill me now" pain stakes, Samoan tattooing is generally regarded as the daddy of them all. Traditional pe'a tattoos spread from the hips, over the buttocks, and down the legs to the knees; for women they're called malu and extend from the tops of the thighs to the tops of the knees. The method involved an au—like a sadistic rake made of bone, shell, and wood—which was dipped in ink and literally hammered into the skin with a small stick or mallet. Taking it like a man (or woman) without complaint was an integral part of the ritual; today the designs are the same, but tattoo machines usually replace the au.

Other tribal methods were similar, or used needles lashed to poles in the same fashion as traditional Thai tattooing, apart from the Maori ta moko. These could be placed anywhere on the body but were usually seen on the buttocks, thighs, and face, and combined tattooing with scarification: The inked lines were chiseled into the skin to create textured designs. Some Maori still use this method, although these days the moko can also be applied using a machine.

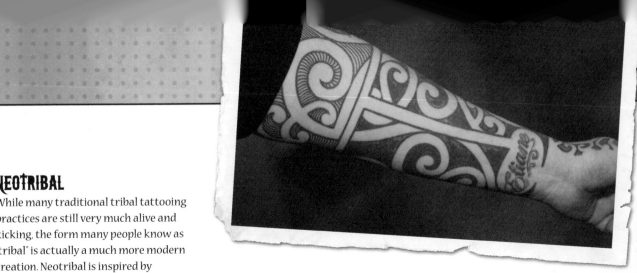

NEOTRIBAL

While many traditional tribal tattooing practices are still very much alive and kicking, the form many people know as "tribal" is actually a much more modern creation. Neotribal is inspired by traditional tribal art and features similar bold slabs of black, geometric patterns, and large designs. However, rather than having a specific meaning it's more about making the inkwork flow within the frame of the body and creating something based on shape, rather than spirituality. The neotribal style is widely credited to Leo Zulueta, who pioneered it in the early 1980s, and is extremely versatile—many designs can be expressed with it, from eagles and dragons to flowers and fairies.

TRIBAL TROUBLE

The modern use of tribal images can lead to accusations of cultural appropriation being leveled at Westerners receiving traditional (or neotribal) tattoos, particularly if they have no roots in the countries whose artwork they are adopting. Some argue that this is akin to wearing another race's culture like a new hat, and is disrespectful to the society in question.

However, others argue that imitation is the sincerest form of flattery, and that the spread of Polynesian tribal tattooing beyond its island boundaries is not only natural, but should be encouraged as a way of sharing histories and promoting understanding between an increasingly connected global community. In the end, perhaps the act of tattooing in general confers membership of a kind of tribe—the international ink collectors?

Of course there's no simple answer. But the debate reminds us that any kind of tattoo needs careful thought, and that tattooing—as Captain Cook put it so well—is "a curious subject for speculation." And wouldn't it be boring any other way?

Tattoo myths

⭐ The arrival of tattooing in Samoa is credited to two mythical sisters who brought tattoo tools from Fiji, singing as they swam the oceans.

⭐ Maori tattoos come from Mataora's pursuit of his wife Niwareka into the underworld, where his facepaint was mocked by the spirits of her ancestors, who wore the ta moko. Begging forgiveness for mistreating her, he was taught the art, and brought it back to the world of the living.

DOTWORK AND MACHINE-FREE TATTOOING

Just when you think you're getting the hang of tattooing, along comes a man with a needle on a stick and artwork made up entirely of dots. Who needs a noisy machine and a load of lines, anyway?

When is a line not a line? When it's a dot, of course. Falling somewhere in between flat- and fine-line tattooing, dotwork tattoos build up images, shading, and patterns using an intricate spread of dots (the clue is kind of in the name). Dotwork tattoos suit any kind of image, but they're quite popular when inking spiritual subjects—particularly those with an Eastern feel. Dotwork can also link to traditional types of tattooing, such as those practiced by Buddhist monks at the Wat Bang Phra in Thailand, which are created by hand using needles mounted on bamboo canes.

MACHINE-FREE TATTOOING —BOFF KONKERZ, DIVINE CANVAS STUDIO

Machineless tattooing has nothing to do with artists loading their fingernails with ink and jabbing at their hapless clients. While dotwork tattoos can be done by machine, some artists prefer to work by hand, as Boff explains.

"I've only ever used one technique: Ink is inserted into the skin using a needle lashed to a small stick. This technique goes by many names (like handwork, or stick and poke), but I prefer the term 'machine-free tattooing.' I favor using only black ink and shade mainly using dots, which is both a stylistic approach and something which lends itself to the technique I use.

"I'm attracted to the work I do because of its simplicity and its reductive nature; I like to achieve a lot using a little. At one point I purchased an electric tattoo kit which I never used and eventually sold. Later on I discovered handwork and knew it was something I wanted to learn. I've never used a tattoo machine and have no desire to ever do so; there's still so much that can be achieved by hand."

THE MACHINE-FREE EXPERIENCE

"The tattooing experience depends on more variables than just the technique used. If a person is receiving a hand-poked piece in a noisy studio or at a convention, for example, alongside people being tattooed by machine, then the only difference they'll probably notice will be the different physical sensation of having the tattoo applied by hand. However, if the tattooing takes place in a more quiet, private setting then there's a greater chance that the client may become aware of the energy transference and the meditative quality of the work.

"That said, most people come simply because of the look of the tattoos. Dotwork is infinitely flexible and most of my work is neither geometric nor religious, although they are areas I happily work within. I'm not any kind of spiritual practitioner, but if people want to see me as that and take something spiritual from the process then that's fine."

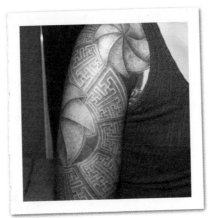

GETTING YOUR DOTWORK TATTOO

"When planning your tattoo you should spend as long as possible researching both the artist and the design. Take your time; a tattoo is not to be rushed into. One thing people should consider is not to go too small. Often when approaching a first tattoo a client will insist that the piece not be 'too big,' when in reality small tattoos simply don't look as good as a well-thought-out, good-sized piece. There's no place in tattooing for pointless, mediocre tattoos any more. We need inspirational work: Go for it!"

Find out more about Boff's remarkable work at www.divine-canvas.com, or visit him on London's Caledonian Road.

Tattooed!

SAKURA AVALON

What appeals to me is that the design wasn't done by a machine, it's all been done by hand. The technique appeals to me more than the designs. It's very gentle; a lot of people think it looks more painful, but I fell asleep so many times. I actually read *The Lord of the Rings* while they were done!

I think it's a much more beautiful way to get tattooed than by machine, and you get to know the artist better as well.

MORE THAN WORDS

Sometimes you just need to spell it out. Script tattoos—featuring words, numbers, and alphabets—let you mark important dates, record people's names, or make a very literal fashion statement.

It's true that a picture can be worth a thousand words, but there are times when only words will do. There are plenty of reasons to include writing in tattoos—dates and names for memorial designs; quotes that mean something to the wearer; extracts from religious texts; personal mottos; labels showing which hand is left and which is right… well, maybe not that one. But words have always been important in tattoos, whether it was a mark of the

legion to a Roman soldier, a meaningful comment on custody for a French prisoner (French prison tattooing is a fascinating subject that's been the focus of many books, and is well worth investigating), or the words "Hold Fast" inked onto a sailor's knuckles to provide strength and encouragement when he was 30 feet aloft in the ship's rigging, staring into the eye of a storm.

Tattooing knows no language barriers, and people choose alphabets and scripts from all over the world and throughout history for their designs. It might be a mother tongue or a second language, the source language of a religious quote, or even a style of writing that the collector finds particularly beautiful. There are no rules. Here are some languages and scripts to contemplate.

LATIN

Ever-popular in tattooing, Latin—the language of European scholarly learning, law, and faith—seems to have an authoritative weight in its written form. Although it's hardly spoken by anyone outside of the Catholic church, Gothic-looking Latin text is hugely popular in inkwork and might reference the mottos of the armed forces, passages from the Bible, or works of literature. Its appearance owes a lot to the illuminated manuscripts prepared by monks in medieval Europe, but alas you won't find many tattooing monks in today's monasteries. (Although if you do, let us know.)

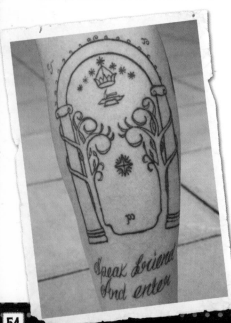

Left: A tattoo inspired by Tolkien's The Lord of the Rings. *Elvish is another popular tattoo script, although not many people are fluent in the fictional language.*
Right: A swimmer has the Olympic Games slogan "citius, altius, fortius," latin for " faster, higher, stronger."

HEBREW

There's been a bit of a craze for Hebrew tattoos in the past decade—stand up Madonna, Britney, and the Beckhams—and they're enjoying a lot of popularity among those wanting a spiritual tattoo (many ancient religious texts are written in Hebrew). However, these need to be approached with caution, as there's plenty of room for error: Not only is Hebrew written right to left, it also has no vowels, as the reader is meant to mentally add them. This makes it easy to lose the context of a single word tattooed on the skin, rendering it nonsense, and of course to put words the wrong way around if you're not familiar with the script.

Caveat emptor!

If you're getting a tattoo in a language other than your mother tongue, the single most important rule is MAKE SURE IT SAYS EXACTLY WHAT YOU THINK IT SAYS. Check, double check, then check again. Get the spelling and the meaning right, or face acute embarrassment later. This is particularly important if you choose a Chinese or Japanese pictogram, in case the translation you're given is inaccurate—it's also vital that the artist is precise, as slight variations can change the interpretation. "Buyer beware," as the Latin above says. (Or does it?)

ARABIC

The almost waterlike flow of Arabic and Persian scripts makes them an elegant choice for written tattoos and allows some calligraphic flair on the part of the skilled tattoo artists executing them. Arabic might be chosen for quotes from the Koran, but as with all Islamic tattoos it's important to be aware that the practice of tattooing is frowned on by some believers, who hold that the Koran expressly forbids it. Others interpret the scripture differently—so do some research before going under the needle!

SANSKRIT

Sanskrit is an ancient language with spiritual associations, particularly with Buddhism and Hinduism. It's known for allowing great clarity of expression, which may explain its popularity as a liturgical language and among the tattooed community. The language might be used to quote Buddhist or Hindu scripture, include extracts from the Indian epics like the Bhagavadgita, or to inscribe mantras and prayers on the skin such as "Om Mani Padme Hum," a key Buddhist chant. For more on "Om," the sacred Sanskrit symbol, see page 61.

GRAFFITI

Moving from a centuries-old spiritual language to aerosol daubings on subway walls may seem like a giant leap, but graffiti has actually been around for many hundreds of years—examples were found on the walls of Pompeii advertising prostitutes, and some Roman examples include gladiators boasting about their sexual prowess. So nothing really changes. Over time, graffiti has evolved its own very distinct look, and each artist or collective develops a signature style that might appeal as a tattoo. "Wildstyle" graffiti in particular has complex rules of form and composition that make it almost impossible to read for non-artists—which only adds to its appeal, naturally.

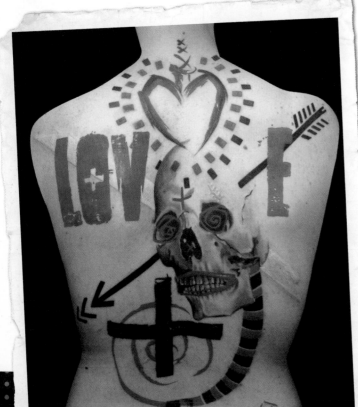

AMBIGRAMS

And speaking of words that are designed to confuse the reader, this is where it can get a bit technical. A simple ambigram is a word designed to read the same whichever way up it's positioned, but there are many complex variations on this theme. In some versions—symbiotograms—the original word changes when it's rotated 180 degrees, perhaps illustrating opposing words (Saint/Sinner, Angel/Devil); there are also mirror phrases that read one thing to a viewer, but something else entirely when the wearer sees them reflected. There's all kinds of fun to be had with this, along with the risk of being trapped in front of the mirror for hours on end giggling at your own personal optical illusion.

There's a lot more to writing in tattoos than the traditional "Mom" and heart logo, and of course there are endless variations, making it a simple way of getting a really personal tattoo. But: Getting your girl- or boyfriend's name inked after a few weeks together? Probably not wise. Buy them a present instead and get yourself a design that you'll always love—no matter what becomes of the relationship.

Top left: An elaborate ambigram, this tattoo reads "aloha" even upside down.
Top right and opposite: Flat-line shapes and text can be combined with surreal fine-line images to make a highly unique tattoo, as these examples by Buena Vista Tattoo Club show.

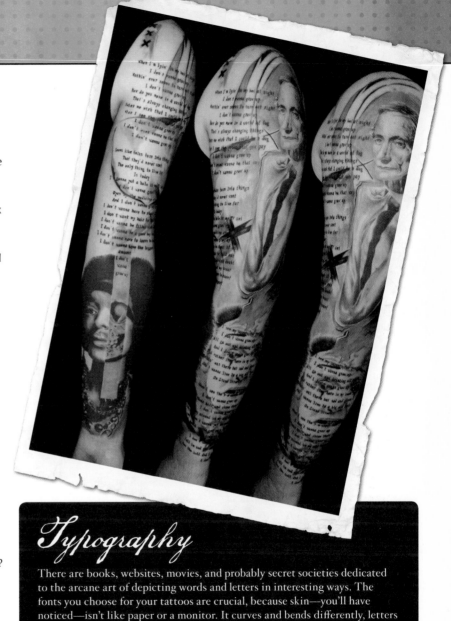

Typography

There are books, websites, movies, and probably secret societies dedicated to the arcane art of depicting words and letters in interesting ways. The fonts you choose for your tattoos are crucial, because skin—you'll have noticed—isn't like paper or a monitor. It curves and bends differently, letters stretch as you move, and ink will spread out over time—all of which needs taking into account when planning your typeface. As a rule of thumb, find an expert in script tattoos, go as big as you possibly can, and try to avoid too much fine detail that might ultimately blur into mess. Also, avoid the Comic Sans font. It seems to make graphic design-type folks really, really mad.

SYMBOLS AND SECRETS

If words are too, well, wordy, and pictures just won't cut it, what can you use for your tattoo? Symbols have proved to be very versatile and have been marked on skin for longer that you might think.

From hieroglyphics in tombs to bumper stickers on cars, we've always been keen to distill faiths, philosophies, and abstract ideas into instantly recognizable images. Originally this may have been a way of giving an illiterate population a simple visual reference; or of hiding the real meaning from the authorities. Symbols may even have evolved to express ideas that words could not.

For the tattoo collector, this gradual accumulation of signs and symbols provides a vault of image choices. Symbols can be rendered on their own as simple blackwork, or appear in full color, woven into an intricate design. They might appear on the skin as an illustration of the wearer's views or beliefs; they might be purely decorative; or they might be there because some symbols still have an air of antique mystery.

The pictograms tell tales of gods, pharaohs, priests, and kings, as well as rituals and everyday events. As tattoos they're perfect for the Egyptologists out there, but also for anyone who feels drawn to the society of ancient Egypt and its views on death and immortality, or with the importance it placed on the sun. Statues hint that the Egyptians themselves may have worn hieroglyphic tattoos, so you'd be part of a well-established tradition. And the man with the dog's head? Anubis, the god of the underworld.

MUMMY TALKS

For centuries the hieroglyphics seen throughout Egypt were a classic example of just such a mystery. Did they represent a language, or just an elaborate cartoon strip? And what was the man with the dog's head all about? The discovery of the Rosetta Stone in 1799 changed all this, giving us a translation of hieroglyphics into Greek that allowed the whole writing system to be decoded.

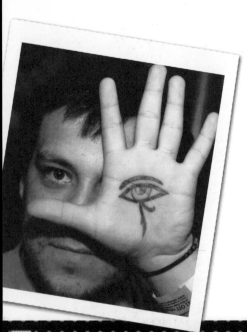

READING THE RUNES

A different god—Odin—was responsible for bringing the runes to the world, according to Norse legends. The runic alphabets are ancient writing systems from Scandinavia whose use predates the Latin alphabet in Europe; the earliest examples date from the first or second centuries BCE, and they were eventually outlawed and fell into disuse during the Middle Ages (around 1100–1200 CE).

Runes are popular tattoos but their meaning is a tricky business, as the Vikings didn't leave any "how to read runes" books written in anything other than… well, runes. No Rosetta Stone here. Which means our understanding is split between what we do know of their original meanings, and the more modern spin put on them by New Age religions. The practical upshot of all this is that any one rune can have several different meanings, so be aware of this when researching designs. The rune for "protection" might also mean "elk," for example—so your tattoo is either a powerful talisman or a shaggy variation on a moose.

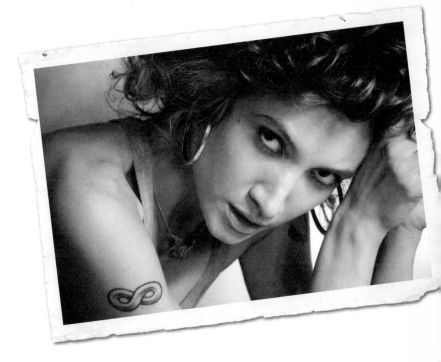

TO INFINITY AND BEYOND

While the meanings of the runes may be obscured by the clouds of history, the symbols we use to illustrate infinite time have no such problems. The more mathematical "infinity" character looks like a wonky "8" after one too many fizzy drinks, depicting the endless looping of existence and providing a handy shorthand for the mathematical idea of a number that never ends (otherwise we'd soon run out of writing space in our math books). It doesn't stop with a scientific concept, though—as a tattoo the infinity symbol acknowledges life, death, and rebirth in a constant cycle, accepting that the universe is immortal even if the wearer is not. (Or it could just point to wishful thinking on their part.)

The Ouroboros symbol—Greek for "tail devourer"—has very similar meanings, but with the added potential for becoming a more striking tattoo image. The circling snake creates and destroys itself simultaneously, mirroring the processes going on out there in the wild, wide universe. It's cunning as it can exist as an armband or lie flat on the skin's surface, and shares the smooth, meditative quality of circles—the perfect expression of Zen for some Buddhists.

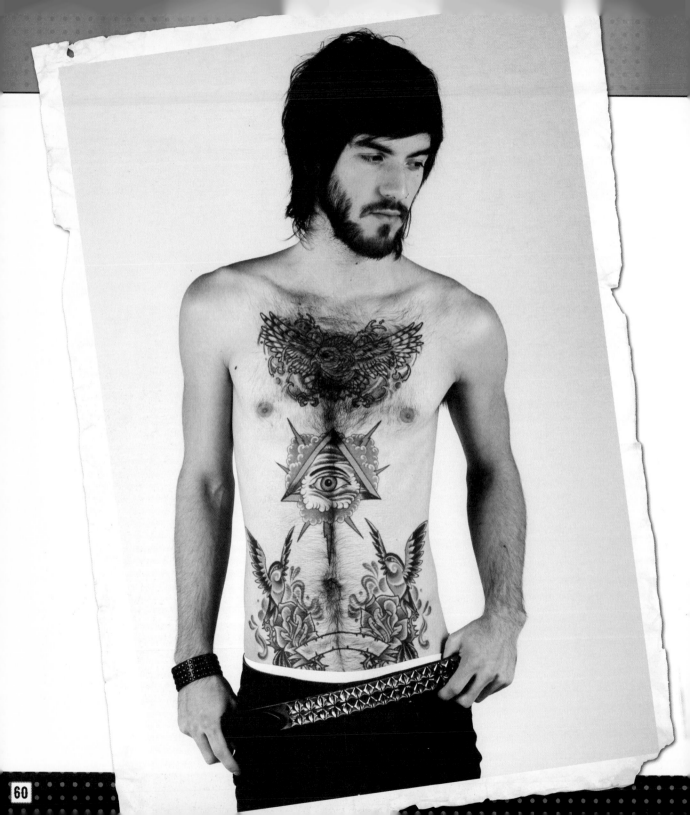

PICK YOUR SIGN

For those searching for a bit of meaning in an endless universe, the movement of the stars and planets can sometimes provide an answer in the form of the zodiac. In the Western version, the "star sign" you're born under is said to partially define your character (quick-learning but impatient for Aries, for example, or charming but flighty for Gemini), with the influence of the planets contributing as well.

Depending on your point of view, the idea that the motion of a distant planetary body—swinging through the howling void, battered by solar radiation and the hostilities of infinite spacetime—will affect your personality or the outcome of your date next Tuesday may seem either profoundly revelatory, or a load of old nonsense. Either way, the symbols for the signs of the zodiac plant the wearer in time by pointing to their date (or year) of birth, might act as a lucky charm, and can signal a belief in astrology or simply the influences of external powers on our lives.

For the Chinese, the zodiac calendar moves in a 12-yearly cycle, with a different animal dominating each year—anyone born in that year will share the animal's traits, such as the cunning of the rat or the loyalty of the horse. According to mythology the order of the animals was decided by a race across the river, judged by the emperor—the ox would have come first but for the sly rat who rode over on his back and jumped ahead at the last moment. The other animals (in order) are the tiger, rabbit, dragon, snake, horse, sheep, monkey, rooster, dog, and pig. Again, tattoos signal a person's birth year and recognize the strengths (and weaknesses) they share with their zodiac animal.

Whatever you want to show in your tattoos, symbols can provide an elegant solution. It's all there: Mysterious worldviews, gods, monsters, ancient languages, infinite space, and, um, elks.

Om

According to some faiths, if there was a deep breath in the void the moment before the universe began, "Om" is the sound it made. This Sanskrit symbol is important to Buddhism and Hinduism and occurs throughout the Indian subcontinent: You'll see it on the largest temple and the most humble homemade shrine. "Om" is many layers of spiritual meaning compressed into diamond clarity, the utterance at the start of prayers, a sign of faith and the syllable expressing life and all existence that will echo on when everything else ends. So it's just as well it makes a really good tattoo design.

KEEP THE FAITH

Tattoos can help people broadcast their faith or remind themselves of it, but they don't have to—some wearers are just attracted to the look of religious inkwork. It works in mysterious ways, after all.

The use of tattoos as devotional symbols is nothing new—we've been at it for centuries. While some people choose elaborate artwork in full color, pictures of religious scenes, or portraits of divinities, others go for more simple designs that still carry a lot of weight. Because the scope for religious tattoos is almost infinite—there's a lot of belief out there—we'll keep it simple here.

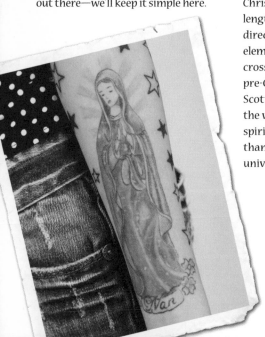

CROSSES

The Latin cross signifies the Christian faith and Christ's death—and by extension God's love for mankind. It's a very popular symbol and can appear in many forms, both simple and spartan or embellished and ornate.

However, a cross isn't a uniquely Christian symbol. With arms of equal length it can point to the four compass directions or represent the four elements: Earth, wind, fire, and water. A cross in the Celtic style can also hint at pre-Christian pagan beliefs and Scottish or Irish heritage, and of course the wearer might not attribute any spiritual significance to it at all, other than taking comfort from an almost universally recognized symbol of peace.

COPTIC TATTOOS

Coptic tattoos often include a simple cross on the wrist, and might show that the wearer is a member of the Coptic church—a minority Christian sect that originated in Egypt. The tattoos are based on simple woodblock designs which are ink-stamped onto the skin and then needled in; they've been worn by Copts but also collected by crusaders and pilgrims to the Holy Land for hundreds of years.

HINDUISM

In some parts of India traditional Hindu tattoos worn by the faithful include lines or dots on the forehead. More common in the West is the "Om" symbol (see page 61), and the pantheon of Hindu deities also provides inspiration—there's some crossover between simple flat-line designs and more intricate fine-line ones, as either approach will create striking images. Popular deities include elephant-headed Ganesh, Hanuman the monkey god, or any of the many incarnations of Vishnu or Shiva, all of whom may answer prayers and bring good fortune or protection from evil to the wearer.

JUDAISM

Historical and textual evidence suggests that protection was also a key part of the Star (or "Shield") of David's original symbolism, and that it appeared on protective Jewish amulets as early as the twelfth century. Although its exact origins are a mystery, it has become a global symbol of Jewish identity and fulfills an identical function in tattoo form; a menorah (a candelabra holding seven oil lamps) is an even older Jewish symbol capable of doing the same thing. Apparently it's more likely that David's actual shield bore the menorah image rather than the six-pointed star, but either design will act as a clear sign of faith.

Far left, opposite; and right: Christianity provides lots of potential inspiration. The Virgin Mary is hugely popular, as are images featuring Christ or angels.

BUDDHISM

In some respects Buddhists don't put too much stock in physical signs of faith, tattoos included, as possessions are one of the key causes of attachment and suffering. In practice though, there are several popular Buddhist tattoos which might serve as a reminder not to get too fond of this material world: The heart mantra "Om Mani Padme Hum" is one of them, (see page 56 for more) as are images of the Buddha himself, the bodhi tree under which he was enlightened, and perhaps the prayer wheels that feature prominently in Buddhist temples.

ISLAM

Although relatively uncommon, Islamic tattoos do exist but it depends on your interpretation of the Koran; whether or not it prohibits tattooing, and whether or not you think you'll be "purified by fire" before entering heaven. Rather than encouraging a trip to the tattooists (or playing with matches), we'll just say that quotes from Koranic scripture and the star and crescent moon symbols are possible designs.

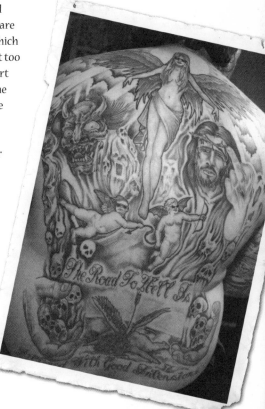

Think before you ink!

Whether or not you're getting a religious-themed tattoo because you're a believer, be aware that not all faiths and people approve of tattoos—so give it some careful thought and make sure you're clear on why you're choosing that particular image. Think about placement, too: Some believe that a location closer to the head or heart is more spiritual and gives a religious tattoo more power.

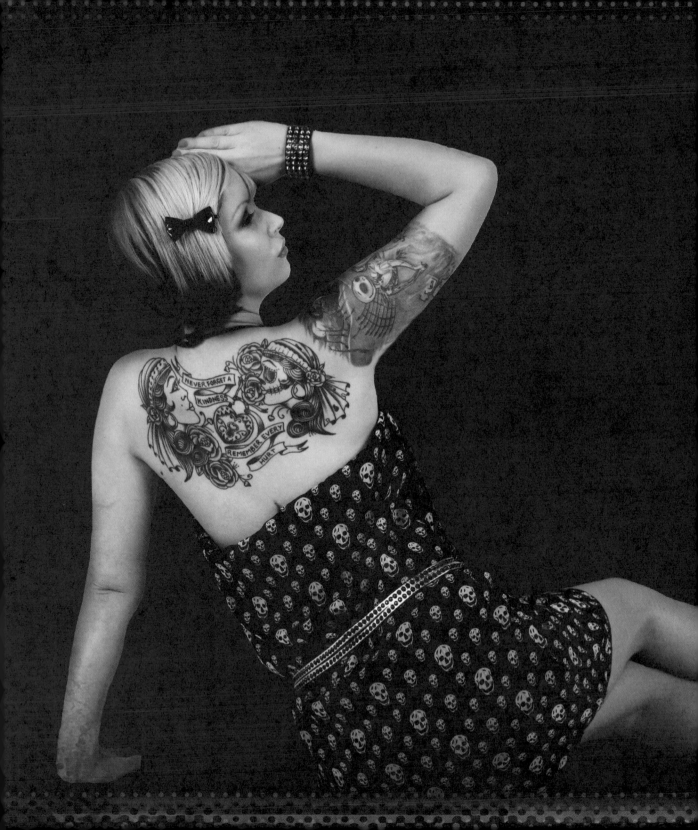

CHAPTER THREE

FINE LINE

This is the place for innovative ink with lots of detail, depth, and shading. Photorealistic portraits, crazed European modernism, aliens, zombies, and everything in between is right here.

NEW SCHOOL

If you're looking for cute kitties, kitsch cupcakes, and rainbow-bright colors, you've come to the right school. Sulky souls with no desire for fun and general quirkiness need not apply.

In some ways, New School art is the unruly child of the tattoo world. It seems to gleefully disregard convention and traditional subject matter, tearing through the color palette with wild abandon and flinging psychedelic ink all over the place, before cornering established ideas of form and composition in the playground and stealing their lunch money. It's bright, brash, and very hard to pin down.

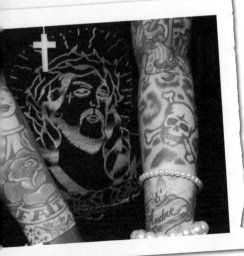

However, this is all on the surface. Although there's no single way to define New School, it's still a style with distinct characteristics when it comes to both technique and subject matter. It borrows tricks from other areas, but makes something new out of them; likewise it can be used to illustrate any subject, but there are some subjects that are uniquely "New School." It's this flexibility that gives it such a broad appeal, allowing artists to develop their own styles under the New School banner, and giving wearers a whole new way of imagining subjects for their inkwork that they might never have considered previously.

OUTLINING THE STYLE

Perhaps the most obvious characteristic of a classic New School tattoo is a thick, almost graffiti-like black outline that looks as if the tattooist has used a needle the size of a permanent marker. It makes the design stand out and sets it apart from other styles, which use outlining in a different way.

Closely linked with this is the color palette of New School art. While traditional Old School tattoos might have a limited range of reds, greens, and blues rendered in a particular way, New School uses lurid colors that border on the psychotic: Neon yellows and greens, saturated primary colors, and lots of contrast create tattoos that resemble a mashup of street art and the Cartoon Network.

None of this is at the expense of technique, though. Look closely at a well-executed New School sleeve, for example, and you'll see the same level of detail and balance of foreground/background as you'd see in a traditional Japanese tattoo. Only in this case it's more likely to feature Homer Simpson and donuts instead of koi and cherry blossom. New School opens the door for more quirky subjects, while presenting them using tried-and-tested methods of composition.

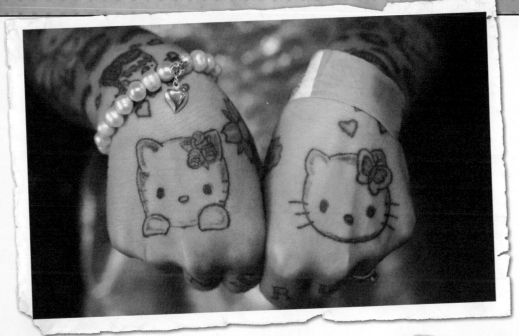

HELLO, KITTY

Although the acid-house paint gun of New School can be trained on any subject, there are a few areas that have become established New School themes. A cartoony element is one of them, either using well-known characters (perhaps in odd ways) or the artist's own creations. This gives some New School tattoos a bright, playful look that distances them from other styles; the biomech kids sit at a different table in the tattoo canteen.

FOOD, GLORIOUS FOOD

Speaking of which, food is another favorite New School theme. Often embracing all that's sweet and sticky, you might see piles of candy canes,

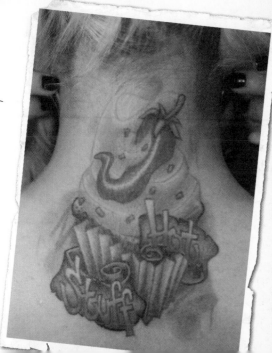

ice cream, and cupcakes making up a large New School design. Expect lots of color and glossy sheen to all that frosting—but done well, the image will still be balanced and never look like a random stack of calories, however asymmetric it may be.

The artist

LEAH MOULE, SPEAR STUDIO

"To me, New School is bold, bright colors with ridiculously fat outlines and also an odd perspective on the design. Personally I think a New School tattoo is something that can be identified from across the road.

"When I started tattooing I did all types of tattoos but I really only feel happy with color work. I like to think of my style as slightly quirky yet bubbly; it developed quite naturally over a few years. My work just gravitated toward the New School style: When I'm given an idea for a tattoo I automatically see it in a quirky, bold, and colorful way. It's difficult for some clients to understand why I don't just tattoo anything, like tribal or black and gray work, but basically it just doesn't suit my art. I struggle to see a finished design in my head if it's anything but my style.

"Obviously I respect all styles but would prefer clients to go to artists who specialize in them, just like the other artists here at my studio.

"Ideally I like my clients to come in with an idea and some reference material so I can see what they're thinking about and then I go away and draw it up as I see it. Again, this is where my style comes in! Of course it's always flattering when you get the odd client who says they have a space and I can do whatever I want, but a little reference material is always nice. Also, all my clients will tell you I think big is definitely better!

"Getting a tattoo is a serious thing; it's for life and you need to find the correct artist for your design. But the subject matter doesn't need to be serious at all, so if you want something that will make you smile every time you look at it, then I say go for it. A quirky and colorful design is just as personal to the person having it done as a portrait of a loved one is to someone else. Tattoos are meant to be fun, if they're done well. And of course they last a lot longer than most other fun things!"

Spear Studio, Birmingham, UK:
www.spearstudio.co.uk

SCHOOL FOR SCANDAL

Cartoon cats and candy aren't the limits of New School tattoos by any means—they're just intended to give a flavor of some of the artwork out there. New School is quite the chameleon, and can feature all kinds of themes, from the religious to the downright sinful, so it's worth putting some time into researching artists when planning a New School design. Having said that, using sweet treats and hamburgers is part of New School's cute attitude: As artist Leah Moule puts it, "Who wouldn't want a cupcake on them for life?"

Facing page: It's all about the New School. This giant piece merges classic ideas of composition with New School inkwork to create a cartoon carnival that's unified and balanced, as well as brilliantly bonkers.

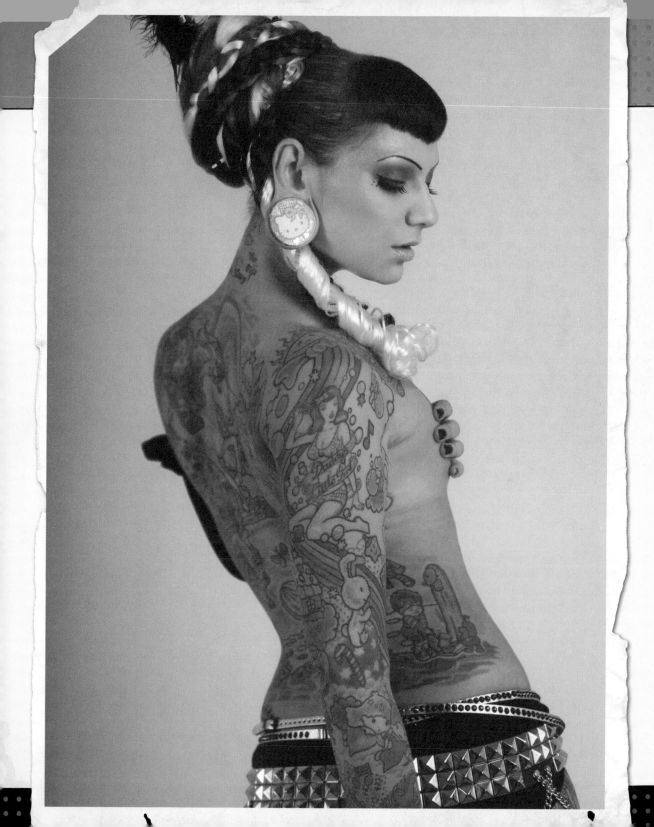

FUTURE SHOCK

Tattoos are in love with all things sci-fi, and you'll find all manner of warp-speed imaginations turning their attention to inkwork, including strange and wonderful biomech.

As *Neuromancer* author (and inventor of the term "cyberspace") William Gibson once said, "the future is not google-able." He was right, of course: It's difficult to see what's really coming down the road, which is why the future is such a popular and fertile ground for writers, artists, filmmakers, and of course tattooists. There's no right or wrong; just your best guess.

Tattoo subjects and styles can be firmly rooted in the past, drawing inspiration from ancient tribal cultures, naval traditions, myths, and folklore. But they don't have to be. Futuristic tattoos can exist purely on their own, leaping from the mind of artist or wearer; or they can pay homage to the imagined futures of creative minds that have already dreamed them up. That can mean everything from 1950s B-movies to ideas so fresh they're still shrink-wrapped.

COMING SOON!

A science-fiction tattoo can draw inspiration from the huge imaginative repository of sci-fi novels, comics, and movies. And yes, that does mean that images of *Star Wars* endure in inkwork, treading the line between geek and chic (or is it just geek chic?): Stormtroopers, droids, Yoda, and Darth Vader appear regularly. Future fictions constantly feed into sci-fi tattoo art, providing a steady stream of robots, aliens, and Terminators to roam across the cosmos of skin and show fanboy (and girl) loyalty, ironic cool, or just a love of outlandish and imaginative machines.

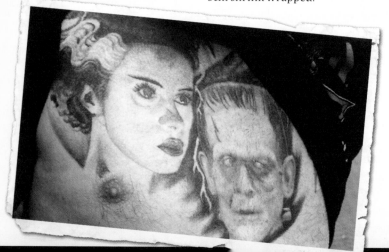

Hybrid art

Ironically, when professional body piercing in the West began in earnest in 1970s America, tattooists wanted nothing to do with it. Happily, times have changed and the scenes exist in harmony, to the extent that they're now combining to form mixed-media body art.

Tattoos are merged with implants, microdermal piercings, and other forms of body modification (such as scarification and branding, where the skin is cut or burned in a controlled manner to create designs) to create textured works, or designs with bright metallic highlights—such as piercings embedded into skulls' eyes. This kind of work is still relatively unusual, sometimes requiring collaborations between different studios—with experts in the relevant modification and tattoo styles—but it remains a possibility for anyone looking for something even more unique.

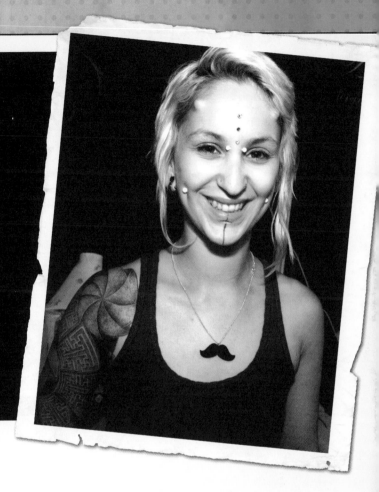

The future's not always bright, either: Sci-fi can explore dystopian themes and broken worlds that appeal to the darker side of tattoos. *Robocop*, *The Matrix*, and of course the graphic art of *2000 A.D.*, *Judge Dredd*, and so on, fit perfectly alongside the shadowy world of blackwork, and black and gray tattoos.

The artist

GUY AITCHISON, HYPERSPACE STUDIOS

"Even after all these years I still find it difficult to describe what I do. I am primarily an abstract artist, and on skin I like to focus my energy on creating a sense of depth, flow and power to my work... sort of what tribal tattoos are designed to do, but with more dimension and way more to look at.

"'Biomechanical', in my opinion, is simply a blanket definition for any dimensional abstract tattoo motif that is designed to transform the anatomy of the wearer. It can be masculine, feminine, aggressive, peaceful, mechanical, natural... it's infinitely customizable. My work has departed from the H R Giger look and has taken on a life of its own, but it's still an obvious branch of the Giger-inspired abstract world.

"I like to work by talking to the client until I see a clear picture in my head; from that point I'm ready to go. In many cases I'll ask the client to look through my portfolio and tell me which pieces they like the most, and why... that gives me a chance to gauge their tastes, since my style can encompass a lot of different wavelengths of energy,

and I want to get it right for each person. In rare cases I will have to tell someone that I think I am the wrong artist for them. Rare, but it happens! Even if I like them personally, we need a parallel vision for the project.

"If you're planning a tattoo, do your research! Look at lots of online portfolios, get referrals. For the best work that fits your needs the most, expect to travel, and expect to wait. If you're not willing to do one or the other, your tattoo will suffer for it. If you make a connection with the right artist, though, you will probably end up hooked on ink, like so many of us."

Guy pioneered the Biomechanical school and is a leading authority on tattoos and tattoo education—find out more about him at www.hyperspacestudios.com.

DO ANDROIDS DREAM OF ELECTRIC SHEEP?

In fact, the world of science fiction and the art it inspires have even given rise to their own school of tattooing. Appropriately for tattooing, an artform that largely relies on the collision of flesh and needle, human and tattoo machine, this style imagines the synthesis of the organic and the fabricated, blending muscle and sinew with wire and steel to form a distinctive style of art: Biomech.

BIOMECHANICAL TATTOOS

As a way of introducing biomech, it's time to go back to the movies. More specifically, one movie: Ridley Scott's *Alien*, the 1979 sci-fi horror flick that updated the haunted house genre by sending it into space. In this case, the thing that went bump in the night was a malevolent extra-terrestrial with acid for blood and more mouths than seemed necessary, which gradually picked off the helpless crew of the stricken starship *Nostromo*.

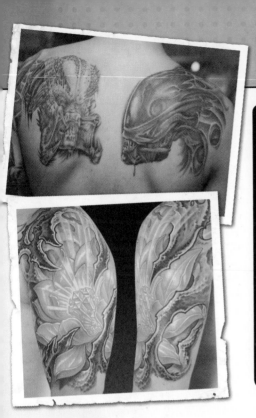

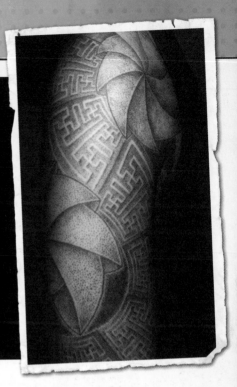

Get inspired

For all your metal mentalism needs, try H R Giger's *Necronomicon* as an intro to his art, or talk to your local custom tattoo artist; as machine interiors are a big part of biomech, you can draw inspiration from anything mechanical—just make sure that Rolex is a fake before you bash it open. Don't forget: The world of comics has been inspiring tattooists for years, so a dip into your local comic store might show you the world you're looking for.

Key to the success of the film was the look of the alien forms and technologies encountered, which were designed by Swiss surrealist H R Giger. His Oscar-winning vision was a flowing fusion of machine parts and organic life, creating a starship that looked like it had been grown rather than built, and an alien that was all natural but appeared metallic, with steely teeth and glinting exoskeleton. It was terrifying and disturbingly beautiful in equal measure.

The biomechanical school initially drew inspiration from Giger's style and the established sci-fi notion of the cyborg, defined by Donna Harraway in her Cyborg Manifesto (*The Cybercultures Reader*, 2000)

as "a cybernetic organism, a hybrid of machine and organism," but personified in popular culture by Darth Vader—a man with robotics bolted on, and a voicebox set to "scary mode."

But biomech tattoos went even further and imagined the human body filled with machine parts, peeling open the skin to reveal pistons and metal, clockwork grafted onto bone and flesh; underneath, humanity was a machine. The tattoos could raise questions of individual identity in an age of robots and production-line culture; they could be nightmarish and horrifying; or they could just look gnarly, dude. Whichever you preferred.

MUTATIONS

Over time the biomech school has evolved, with different artists bringing new ideas and interpretations to the style. The original meat-and-metal combos are still popular, but there are also more flowing, organic (even abstract) creations that simply suggest an artificial look without explicitly ripping the chest open to show an android heart. Some biomech tattoos are more like sci-fi murals, throwing otherworldly shapes onto the skin; some are soft and colorful; others retain a definite link to the dark side, splattered with blood and gore or suggesting places where no-one can hear you scream.

WAR AND PEACE

Designs featuring the tools and trappings of combat have been a fixture of tattooing throuhgout the centuries—and to balance things out, so have images promoting a less violent approach.

When you've been around for as long as tattoos have, chances are you're going to have been involved in a few scrapes. Warriors and pacifists have been inked for centuries, with the artwork serving a range of purposes; the range of schools, styles, and techniques out there today mean they can translate their beliefs into ink even more eloquently.

BADGE OF HONOR

The simplest function of a military/combat-themed design is to identify the wearer as a warrior or soldier, perhaps displaying pride in their position, or a sense of camaraderie and belonging. It might have been a mark of the legion for a Roman, or a more contemporary insignia showing the particular division of the army that a person belongs to, perhaps including the regimental crest or a symbol associated with it. Equally, an image associated with peace can display the exact opposite: Someone who chooses not to fight, and is proud of the fact.

ON THE FIELD AND IN THE RING

Tattoos can do more than indicate the wearer's status or fighting spirit—they can help in battle, too. This kind of tattooing has roots right back in tribal tattoos: The designs were intended to make the warrior appear more ferocious and cause the enemy to hesitate, giving a tattooed fighter the advantage. Inkwork could also relate to prowess in battle, showing the number of enemies a person had killed—again, an intimidating decoration to come up against.

Sticking with the idea of intimidation (but hopefully moving away from the killing side of things), it's probably no coincidence that many boxers, martial artists, and cage fighters have large tattoos, often with fearsome designs: The first blow of a fight is usually psychological, and tattoos can certainly play a part in that. If the guy opposite is smothered in grinning skulls, blood, and scrolls proclaiming "I must break you," it's going to make an opponent think

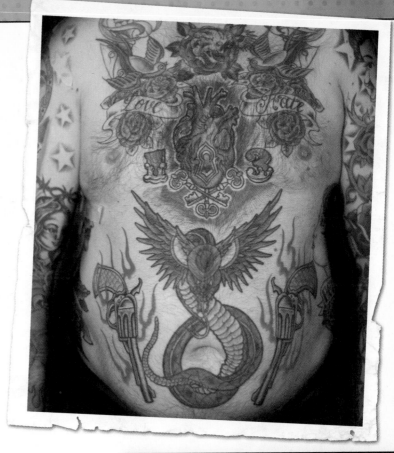

twice. Unless their own skulls are bigger, of course.

PEACE BE WITH YOU

If you're a lover, not a fighter, body art can also suggest peaceful ideals and aspirations. They might be personal and reflect the wearer's general attitude, or perhaps be more philosophical or political, representing a more active desire for peace—in direct opposition to the more belligerent stance of martial tattoos. They could also be religious, pointing to spiritual concepts of peace as practiced in the wearer's faith.

Whether it's to call out to the world at large for a bit of the old ultraviolence, or to get everyone to hug instead, there are a few tattoo designs that have been getting the job done for some time.

The departed

A tattoo can act as a memorial to lost comrades and loved ones—traditionally a swallow pierced with a sword or dagger indicated someone lost at sea, while any number of broken blades, guns, or helmets could point to loss of life. A less obvious design is a butterfly —considered to represent a warrior's soul by Japanese samurai—and of course the red poppy is a potent symbol of remembrance throughout Europe, where it commemorates World Wars I and II, but also fallen troops in general.

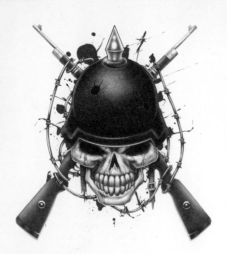

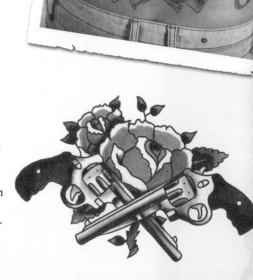

WEAPONS

Any kind of weapon, from swords and daggers to guns and ammo, is bound to carry a whiff of death and danger with it. That might be exactly what some people are looking for from a tattoo design, from Old School daggers to black and gray sci-fi weaponry.

However, there can be more to it than that. Swords, somewhat old-fashioned weapons, might represent ideas of chivalry or honorable combat; they might show the wearer wants to protect things—like friends or family—or it might be that they'd rather be out fighting dragons. Daggers, on the other hand, carry suggestions of swift strikes and close combat, pointing at hidden dangers, and of course the feeling of being stabbed in the back.

Guns are a bit different, and can be anything from gratuitously violent and showy, just for the sake of it, to sly and knowing—pistols pointed at the heart can suggest love, and all the dangers and potential heartache that comes with it. And then there are the ones that point to the groin, suggesting risky pleasures of an entirely different kind. Urban representations of guns tend to have a more edgy feel, aligning them with a certain gangster posturing; Old School and neo-traditional art, which make weapons less realistic and more symbolic, are popular styles for giving guns a more subtle meaning than "bang bang, you're dead."

WARRIORS

Including the figure of a warrior in your inkwork might suggest an interest in a specific historical period—such as the Roman Empire—or it might point to the wearer's heritage. It can also suggest belief in the ethics of particular types of warrior: A traditional Japanese tattoo of Samurai can exist as art in its own right, but it can also signify the Bushido warrior code, with its strict rules of conduct and loyalty. With increasingly realistic portraits out there, it's also possible to have historical figures as tattoos, showing admiration for their achievements.

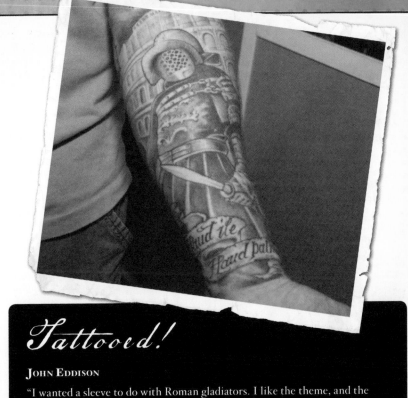

Tattooed!

JOHN EDDISON

"I wanted a sleeve to do with Roman gladiators. I like the theme, and the phrase 'no guts, no glory,' because if you don't do anything in your life you're never going to get any glory, and that's what the gladiator represents."

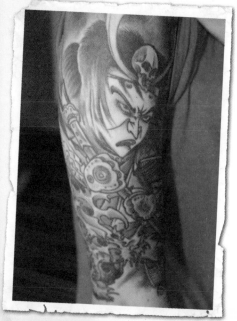

PEACE EMBLEMS

Tattoos signifying peace can be symbols, people, or images that carry powerful metaphorical meanings. The Campaign for Nuclear Disarmament (CND) logo is a simple image which carries both philosophical and political significance, for example. A dove is an internationally recognized symbol of peace, and can have religious undertones for Christians linking the bird to the Holy Spirit. Other spiritual symbols, like the lotus flower or a meditating Buddha, can also suggest peace: Either the kind achieved through meditation, or through not hitting people with sticks—the Buddha approved of both approaches, after all.

PICTURE PERFECT: PORTRAITS AND REALISM

This kind of tattooing is all about capturing faces and features on the skin, and might include celebrities, famous characters, or perhaps friends and family. It's also often about trying to get lifelike results through body art—like a Polaroid you can't throw away.

On one hand, getting a tattoo of someone's face on your skin can seem as sensible as a rub-down with a cheese grater followed by a shower in lemon juice. The highest percentage (16 percent) of ink-choice regret among tattooed people was due to a name in their tattoo, according to a 2003 Harris Poll; given that portrait tattooing is improving all the time and more people are going with it, surely there's even more scope for cursing among those who got the face to go with the name?

However, there are many ways of looking at portrait tattoos, and they don't all have to be the result of a hormone rush in the veins of a lovestruck teenager. People have carried pictures of their children, wives, and partners around in wallets and purses for decades; you could argue that portrait tattoos fill exactly the same function—and you'll never leave them in the back of a taxi with all your money, either.

MEMENTO MORI

Another potential function of the portrait tattoo is as a memorial. Many designs serve this function, from crosses to swallows, but a portrait is an increasingly popular choice as tattooists working in the realism school grow more and more proficient. It's hard to argue with a tattoo created to act as an indelible reminder of a life now passed.

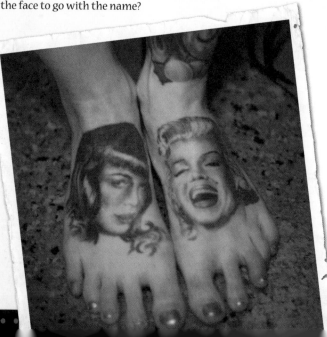

FAMOUS FACES

Portrait tattoos don't have to be restricted to friends and family. Actors, musicians, sportspeople, and even historical (and fictional) figures can be the subject, if a person is a big enough fan; it's not uncommon to see portraits of Marilyn Monroe, Bettie Page (the original pinup girl, so no surprises there), Einstein, and even Salvador Dalí. The reasons vary, from aesthetic appreciation of their features (particularly in the case of Marilyn and Bettie) to admiration of their work, or inspiration drawn from their example; some people simply love the character a person has played enough to get a tattoo of it—see left for living proof. We've all had posters on our walls at one time or another—perhaps this kind of tattoo is an extension of the same idea, but with more ink and less Blu-Tack.

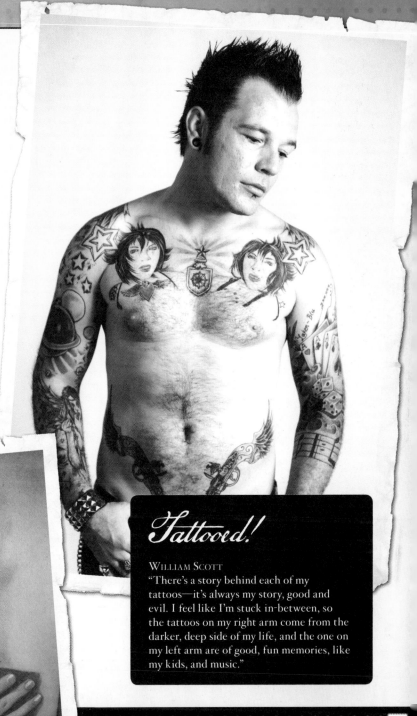

Tattooed!

WILLIAM SCOTT
"There's a story behind each of my tattoos—it's always my story, good and evil. I feel like I'm stuck in-between, so the tattoos on my right arm come from the darker, deep side of my life, and the one on my left arm are of good, fun memories, like my kids, and music."

The artist

ODDBOY, REAL ART TATTOO

"Realism has always attracted me. I've been fascinated since childhood with drawing or painting something that looks as though you could reach out and touch it, which naturally drove my tattoo style. I began experimenting with realism in black and gray early in my tattoo career, but as time went by I realized that color can change the mood of a tattoo completely. Blues can add sadness or detachment, reds can add a feeling of passion or intensity, etc. Colors allow me to be more of an artist in a tattoo, rather than a photocopier!

"There has definitely been a surge in realistic tattoos recently. I came into tattooing from an art background, and a lot of the newer school of realism guys are armed with artistic knowledge that allows them to push the boundaries that little bit further.

"There are a few challenges that only really apply to realistic work and portraits. One of the main challenges of a portrait is the fact that it has to be done in one session. There's no outlining involved so it's not something you can come back to: There's too much risk of losing the likeness. With color portraits specifically, we work with subtle blends of skin tones, which is a real challenge when your background is someone's skin! But I think the possibilities on skin are as limitless as the possibilities on canvas to a large degree. I'm starting to see a real identity coming from new tattoo artists which brings us ever closer to the standard of fine art. I love the way the lines are blurring now between traditional art media and tattooing. There's something that can't be matched about tattooing. To truly wear your heart permanently on your sleeve for all to see is a bold and enticing statement—I'm just blessed that I get to help people make those statements every day.

"When you're planning a tattoo, research your artists! Really get out there and look at the quality of work that's on offer. Tattooing is rapidly approaching the realms of fine art and it seems a shame when people settle for second best just because they're not aware of what's really possible. You're going to wear this for life, why not make it the best it can possibly be?"

THE REALIST SCHOOL

Portraits, whoever the subject may be, fall into one of tattooing's more dynamic schools. Realistic inkwork is improving and changing all the time as artists push the boundaries farther back, and as the quality of tools and ink improve. A further factor might be the increasing number of classically trained artists coming through the art schools with a different approach to tattoo techniques, bringing their experience of portraiture—and of course photography—with them into the studio.

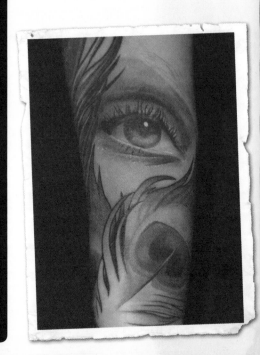

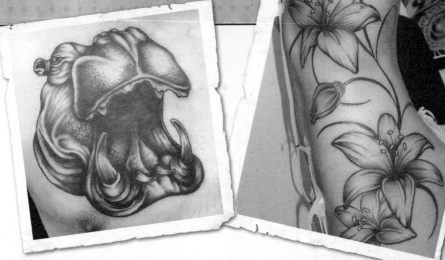

Realistic tattoos don't have to be of people—the techniques can be applied to any subject in an attempt to create a tattoo that is as close to the real thing as possible. This can mean a lot more work than you might think. For example, the arrival of light into an image isn't always a concern with flat-line tribal tattoos, Old School designs, or even New School ones—shading is important, but isn't intended to replicate a light source. When artists are working on a realistic tattoo, though, they have to take this into account – where is the light coming from within the image? And is it being treated consistently throughout? With portraits this can be especially tricky: If the artist is working from a photo, they have to translate the play of light on a 3D subject captured by a 2D image onto a totally different 3D surface—the human body. Brain… hurting.

This school is about much more than achieving vaguely real-looking caricatures of people, objects, and animals—it's about bringing fine art and photorealism into the tattoo realm, and creating images that people wouldn't have believed possible just a few years ago.

TOTAL LIFE FOREVER

There's one question that can't be answered yet, which is: "How good will this kind of tattoo look in ten years?" High-quality realistic tattoos using top-grade inks and new art-school techniques simply haven't been around long enough for people to judge how well their intricate colorwork and detail will stand up to the test of time. Some artists like Last Rites' Paul Booth have spoken about using Photoshop to simulate fading over time with their designs, which is cunning in the extreme—but of course everyone's skin is different and individual tattoos age in their own unique way, so only time will tell. But on the other hand, some argue that you don't really get a tattoo if you're genuinely worried about how it will look in a decade… so who cares? It's down to individual choice—but chances are if you take your time, choose a design and artist wisely, and get some great work done, you won't mind how it ages anyway.

Check out

DAVE PERRY—www.revolvertattoorooms.co.uk
JOSHUA CARLTON—www.myspace.com/greatamericantattoo
CECIL PORTER—www.cecilportertattoos.com
PAUL NAYLOR—www.indigotattoo.com
ODDBOY—www.realarttattoo.co.uk

HORRORSHOW

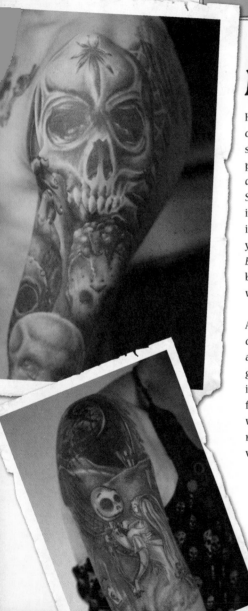

Are you sitting uncomfortably? Then we'll begin. Horror tattoos really let the imagination go wild and can pull many different styles and techniques into their bloody embrace.

Horror, in whatever form it appears, can be an emotive and controversial subject. Those that love it might have preferred genres of horror movie and director, never touch any novel unless Stephen King had something to do with it, and could nip off at the drop of a hat into the nearest graveyard and give you a word-perfect monolog version of *Evil Dead*, complete with the scary eyes bit. It's thrilling, escapist, imaginative, witty, and often thought-provoking.

And those that don't love it, of course, simply can't see the point of all that gore, terror, violence, and general awfulness. The body count is depressingly high, endings usually futile, and you simply cannot hit a guy with a shovel enough times to stop him reappearing at the window. Who would voluntarily submit to being frightened?

Clockwise from bottom left: Tim Burton-inspired ink; the ever-present skull collection; unsettling reversals—like girls killing teddies—are used for scary effect; a treasure chest of horror standards.

Horror tattoos are not immune to this argument, and there's no right or wrong answer. However, chances are the "Why would you want that?" question arises more with this kind of tattoo than with, say, a pretty flower or a butterfly. It's horror. It's meant to attract attention, and it will. If you feel the path into darkness is the one for you, you might want to have some answers ready for the curious people who encounter your ink. (Simply trying to bite them isn't all that polite, unless it's that kind of party.)

HORROR GENRES

This kind of tattoo is more about the theme than the school of artwork it falls into, so horror tattoos can be blackwork, black and gray, color—it's very flexible. Much of it depends on the kind of image you're after, although a lot of the time the subtleties of black and gray make this a great choice: It allows for lots of detail, depth, and gruesome glistening white effects on leaking fluids, bubbling brains, and other treats.

Check out

PAUL BOOTH—www.darkimages.com
BRANDON BOND—www.allornothingtattoo.com
STEVE PRIZEMAN—www.eternal-art.co.uk

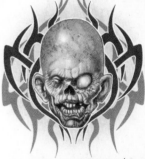

SEEKING INSPIRATION

As a would-be horror tattoo collector, there are plenty of places to seek images to inspire your ink. People often use movies as a starting point: Classic monsters, creatures from black lagoons, vampires, and zombies make regular appearances. Designs might be based on portraits of characters, realistic stills from the films, or even iconic posters. Equally, graphic novels, TV shows, and even folk tales and mythology can provide suitable characters and ideas— European folklore is full of dark tales to satisfy the most gloomy imagination (see When there's no more room in hell, on page 84, for more).

If you don't have a specific image or meaning in mind, the other option is to find a custom artist specializing in horror work—and there are many great ones—and unleash their warped needlework upon your skin. You'll be able to discuss ideas and suggest the kind of feel you want the piece to have, and you'll end up with something totally unique. As ever, tattoo magazines are a good place to start looking, as they'll feature the latest work from artists in every style.

Horror tattoos can be intimidating, frightening, works of realist art, or Hammer-horror style cartoon-grotesque. They can appall and amuse in equal measure (like horror of any genre), but one thing's for sure: Like Leatherface kicking the door in, they'll certainly make an impression.

When there's no more room in hell

MEANINGS OF SOME COMMON HORROR CHARACTERS

Some of the creatures in horror films and fiction have been around for hundreds of years, and have more symbolism than you can shake a chainsaw massacre at.

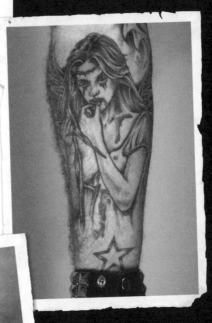

Clockwise from bottom left: Potraiture adds more impact to the design; a simpler blackwork approach; corrupting the Old School gypsy girl in zombie style; giving the dog (or wolf) a bone.

VAMPIRES

Demonic blood-drinking creatures existed in Hindu mythology and Ancient Roman and Egyptian superstition long before the word "vampire" entered the language. However, things really got going in the Middle Ages in Europe, when outbreaks of syphilis and the plague were attributed to unnatural creatures, and doctors merrily staked corpses, believing them to be undead—when in fact their ruddy glow and weight gain was a normal sign of decomposition. Building on these superstitions, novelists Bram Stoker and John Polidori wove supernatural tales of terror that tapped into contemporary fears of the unknown and the foreign, and gave us the vampires we know today. Vampire tattoos can reflect these European Gothic sentiments and suggest evil, lust, repression, and invasive sexuality (think about those penetrating fangs), but also have an air of tragedy—the vampire has no soul and is condemned to live by bringing death. Moody teenage vampires are something completely different, of course. Pesky kids.

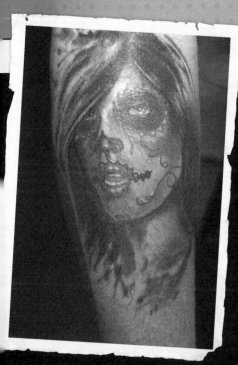

WEREWOLVES

Traditional European superstitions have a lot to do with our contemporary view of werewolves, but the man/wolf story stretches back to Ancient Greece—Ovid wrote about werewolves in the Metamorphoses, and in mythology Zeus punished Lycaon by turning him into a wolf. In European folklore werewolves were sent from hell, or could be the result of witchcraft; again, wolf allusions in Dracula linking the vampire to packs of wolves played on a fear of the animals in a time when fatal attacks were not uncommon. Symbolically (and therefore in horror tattoos) the werewolf represents something wicked and shadowy—the rational mind subverted by the beast within, ruled by our primal nature, and subject to fits of brutish wrath.

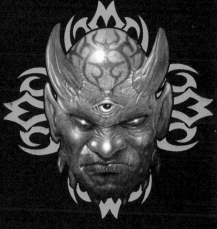

DEMONS

Demons pop their horned heads into every culture around the world. Satan can be viewed as a demon in the Christian faith; Hinduism and Buddhism have scores of different ones to represent evil and negative actions; the djinns of Islam have also been interpreted as demons. And then there's the chap with pins in his head from Hellraiser, and all manner of creatures from the pit in fantasy literature. Demons represent forces from the dark corners of life, and might appear in tattoos to encourage some real ones to show up, or as a way of frightening them away if they do (as well as making the wearer look pretty intimidating).

ZOMBIES

The zombie can be little more than shotgun target-practice in its Hollywood form, but can suggest other things through its mindless shufflings—mortality and the eventual decay of the flesh, for a start. Zombies are nightmarish visions of a literal living death, but on a metaphorical level can point to anything—a person or a wider society—going through repeated actions without thought, simply shambling from one act to another with no direction. They've been used to take swipes at mall culture, mindless consumerism, and other acts of collective brainlessness—your tattoo could slyly point to any of these things, as well as scaring small children.

BLOOD and INK

MODERNISM

We've arrived at the cutting edge of tattooing, where everything is changing. Contemporary tattoo artists are really pushing back the boundaries and breaking conventions, creating whole new ways of working and extraordinary art.

Tattooing has been around for thousands of years and just keeps rolling. It hasn't done this by standing still—we're not all still queuing up for the blue crosses Ötzi the Iceman wore behind his knee, or swallows to show how many nautical miles we've clocked up under Captain Cook. Instead, tattooing reaches out to embrace new techniques all the time, with tattooists bringing art-school sensibilities and modern graphic design ideas into the studio. Here are just a few.

TECHNOPHILIA

It's not uncommon for tattooists to use software like Photoshop while they work, to grab an image of a work in progress and play with it, altering lights and colors and so on before they commit it to skin. Some artists take this idea even further and create work that looks digital on the skin—pixellated tattoos might have a contemporary feel, or a retro twist that recreates the feel of old arcade games on the wearer, for example. There are even experiments in 3D tattooing out there, but it does rely on viewers having some 3D glasses to hand (so always carry some in case you go inkspotting).

The artist

MR HALBSTARK

"My style is hard to pin down. It's graphical, dirty, easy-going, realistic and maybe playful? Actually, all I've done is swap my sketching on paper to sketching on skin!

"I find being able to have my artwork on someone's body quite tantalizing. I like the traditional tattoos but I much prefer graphical ones. I have to like my work, and if the customer does too then that's just perfect.

"I have been drawing since I can first remember, as I studied graphical design for a time I was quite sure this was the direction I wanted to take. For me it's a question of loving my work and not just earning money tattooing any old thing. I'm not in it for the money. I could earn more by tattooing everything but I want to be proud of what I do. Different artists who have been true to their own styles have influenced me over the years—for instance, Mark from swastika-freak shop in Germany has influenced my work quite a bit. He just does his thing, even if it means eating pasta with ketchup at the end of the month.

"A lot of my clients just give me a free hand, they say 'you are the artist, not me,' and I like that. Others like to get inspiration through my sketch book. That's always very satisfying because sometimes something new is created. I like to have clients that I can get on with so we can both have a good time and maybe some fun, it makes the work even more enjoyable.

"Take your time and think about what you really want when you're planning a tattoo. Some people take more time choosing a new mobile than they do finding a good tattoo artist. For me, buying sneakers for $100 that will maybe last a year is a lot of money compared to paying $400 for a good tattoo that lasts forever."

Mr Halbstark is a traveling tattooist—pin him down at myspace.com/halbstark_one.

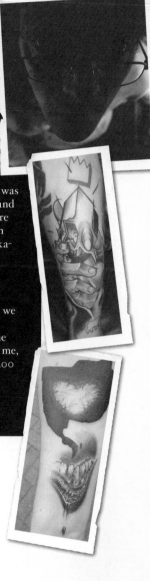

DRIVEN TO ABSTRACTION

Sometimes tattoo subjects fall into a handy category, like 'Haida tribal,' but sometimes the ideas are a little more tricky to pin down. Not every painter does landscapes, and not every photographer works in a portrait studio—some create abstract work that falls down the cracks between categories. Tattooists are no different.

Anything and everything can become an abstract or surreal tattoo; it's all in the execution. For example the skull, one of the most common ink images, can be imagined in countless ways, looking like it's been slapped on with paint by a drunken monkey, or sprayed on as graffiti by a cheeky one. Likewise, any traditional image can be given a surreal tweak or abstract adjustment in the hands of the right artist.

Of course, you don't need anything as solid as a definable image to act as the foundation. Some artists simply use lines, slabs of color, or scratches and splatters to create negative space on the skin, using the body as an expressive canvas for suggesting movement and shapes without being hemmed in by anything so mundane as an actual "subject." In his *Tattoo Bible* (Jazz Publishing, 2010), Alex Guest used the contemporary critical term "Art Brut"—"rough art"—to describe this kind of subjectless inkwork, hinting at how cutting edge and potentially subversive it is.

GRAPHIC DETAIL

Not a million miles away from abstract forms, tattoos influenced by a collision of realism, graphic design, and even comic book art are spreading their way across the skin of tattoo wearers. Showing that the mold-breaking approach of some modern artists doesn't have to be serious, this style rams its tongue firmly in its cheek and conjures comic panels, Manga-like characters, scrapbook sketches complete with scruffy linework, and gleefully plunders the latest ideas in design. Definitely one for the cool kids.

BLACKLIGHT TATTOOS

For those looking for a really unusual approach, or who simply want to look like a rave skeleton from the early 1990s, there's always the blacklight technique. It's the same theory as regular tattooing, but uses special inks which glow under UV lighting; some tattoos can be almost invisible until viewed under appropriately luminous conditions.

There are conflicting views about this kind of tattooing within the industry, mainly stemming from the fact that it's a relatively new idea, and as such the inks and tattoos haven't been subjected to long-term testing. Although some suppliers claim the inks are perfectly safe, it's a good idea to speak to a few artists (some of whom find the inks hard to work with) and do some solid research before deciding whether or not to glow in the dark.

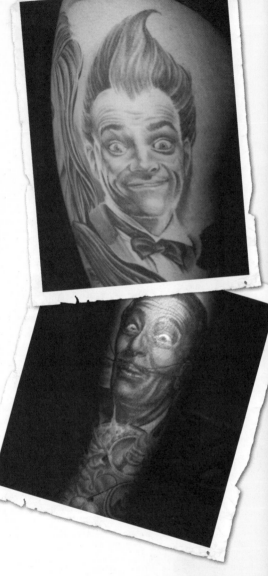

A modernist manifesto

BUENA VISTA TATTOO CLUB

Nobody is creating work like Simone Pfaff and Volko Merschky, the tattoo artists at the heart of Buena Vista Tattoo Club. It's so unique they even had to give it a name: realistic trash polka. Here's what it's about in their own words:

"We've been working as tattoo artists for more than 15 years now, and have developed a totally new and unique tattoo-style we call 'realistic trash polka.' These tattoos are known for their combination of realistic pictures and graphical elements: for example a mixture of a photorealistic portraits with a bigger graphical area, large 'brush strokes' or other abstract motifs. We often use plain black areas against realistic or red elements to create a striking contrast between color. (We use other colors as well, but always in a discreet way!)

"Each tattoo is one of a kind, and we always create completely new designs to ensure we constantly develop our style and don't copy ourselves. To do this we adopted a unique approach: we're the first tattoo artists who don't work to customers' demands. We create the designs on our own, and we only tattoo our own work—the customer can give us a vague idea for the design but has no influence over the final form of the tattoo. This means a new era of custom work.

"Deciding to get a realistic trash polka tattoo means choosing this unique style and buying a picture on the skin in the same way as commissioning and buying a picture from an artist in a gallery. Through this totally new way of working we're trying to make the tattoo business more like art itself and less like a service. We've abandoned the old fashioned and traditional ways of working and are starting a new era of tattooing as an art form; we're also using images in our work that don't fit into classical tattoo designs.

"Our artistic interests are also a big part of our free time. We paint, compose our own songs, and are planning some exhibitions of our artwork."

To join the movement, visit www.buenavistatattooclub.de and prepare to leave your jaw on the floor.

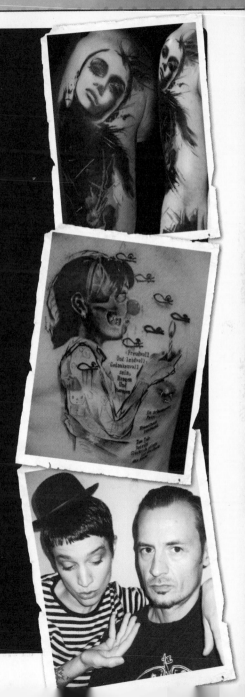

THE BEAT GOES ON

Drummer boys, riot grrrls, gangbangers, punks, emo kids, goths—stick them in a jar together and they'll fight. But they've still got one thing in common: Their music inspires lots of tattoo art.

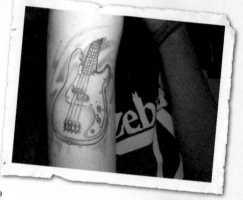

Tattoos have been the support act for different kinds of music for a long, long time. Their association with rebellion made them ideal companions (along with DIY body piercing) for the original punk movement, they've accompanied monsters of rock all over the world, and it's hard to imagine any incarnation of metal without corresponding inkwork. Getting a tattoo has almost become a rock and roll cliché, immortalized in song lyrics from heavyweights such as The Who ("Tattoo") and Tom Petty ("Into the Great Wide Open"), as well as more recent outfits like Brooklyn's The Gaslight Anthem ("Old White Lincoln"). A tattoo goes with rock and roll like a Fender Stratocaster, a haircut that makes parents frown, and a Jack Daniels hangover.

Rock music isn't the only genre where tattoos have found a home. Ink is just as likely to be seen on modern shiny popstars, R&B artists, rappers, and doubtless a cellist or two (although it's hard to tell as they're hidden behind their instruments); you only have to glimpse a video or gig to see how far into the music world tattoos have spread.

FANS UNITED

Getting a music-related tattoo isn't just about the stage image of global megastars—at its heart, it's all about loving music and showing your allegiance to the styles, sounds, and artists you care about, as well as the attitudes your music has toward life and the world in general. Music has always been something of a badge of identity for people, giving fans a sense of community and belonging, so tattoos are a natural extension of this. Inkwork inspired by the music you listen to, play, or gently obsess over is a great way of showing how important it is to you, and displaying that aspect of your personality.

As for the kinds of images people choose… they can be inspired by every piece of music ever made, so there's rather too many to list here. But some general areas might include:

✪ **DESIGNS REFLECTING THE SOUND, FEEL, AND PRINCIPLES OF A BAND/ARTIST.** For example, early punk's contempt for authority might suggest anarchy symbols or skulls and crossed bones; some styles of R&B and hip hop celebrate gang and thug lifestyles with ostentatious gangland tattoos, guns, and ammunition; or a horror tattoo could be inspired by thrash and death metal's preoccupation with dark imagery and the macabre.

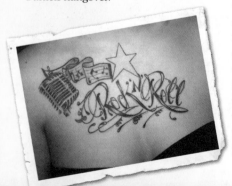

✪ BAND LOGOS AND ARTWORK.

The real die-hard fans might choose to go with their favorite act's logo on their skin, but there's also the artwork a band has created for their records—Iron Maiden's mascot Eddie is a good example, a rampaging undead zombie-monster-thing marching across their albums and their fans' flesh alike.

✪ BAND MEMBERS THEMSELVES.

Many bands have created distinctive images and stage personas to go with their music, which fans might reflect in their choice of tattoos, or they might go for portraits of the musicians themselves. (If you're in any doubt that this happens, try tapping "Kiss tattoos" into Google, and enjoy.)

Turn on, tune in

We need something to deliver music into our ears. Over the years that's included gramophones, record players, boomboxes, and iPods—they can all be turned into tattoos by those that love both the object itself, and what it stands for. By extension the world of music has created icons in the form of vinyl, record labels, and even a little dog looking up at the sound of His Master's Voice, any of which can become a tattoo. (Music fact alert! The dog listening to a gramophone in the original HMV image was a fox terrier called Nipper.)

Who's tattooed?

A few musical folk, and their ink:

- Travis Barker (Blink 182)—ghetto blaster and microphone on stomach

- Robbie Williams—notes and lyrics on back

- Pink—"What goes around comes around" on right wrist; also infinity symbol

- Dave Grohl (Foo Fighters)—tribal designs on upper arms

- Joshua Homme (Queens of the Stone Age/Them Crooked Vultures)—Old School scroll motif, right arm

- Beth Ditto (Gossip)—Old School anchor, left arm

- Marilyn Manson—pretty much one of everything.

- Henry Rollins—Grim Reaper on right arm

- Billie Joe Armstrong (Green Day)—skull and crossbones, word "Punx" on torso

- Courtney Love—flowers and cherry blossoms on arms/chest

- Lenny Kravitz—oriental dragon on chest

- Brody Dalle (The Distillers/Spinnerette)—dragon on right arm

- Rihanna—stars, Roman numerals, Arabic script

- 50 Cent—"South Side" backpiece

- Lil' Wayne—prayers, crosses, guns, Rolls Royce logo, and almost anything else too

KEEPING SCORE

Musical notes, staves, and even guitar tab can be turned into inkwork. Music lovers might choose a favorite song or piece—from Gregorian chants to death blade electro-core (it could happen)—or more simple musical notation, such as a treble or bass clef or a single note, to signify the importance music has in their lives.

Musicians and vocalists might go further, of course, and have their instrument of choice inked onto them. Guitars, drums, and microphones are popular, but you might also see the sound holes of cellos in the small of the back—any and every aspect of music has been turned into a tattoo by someone, somewhere.

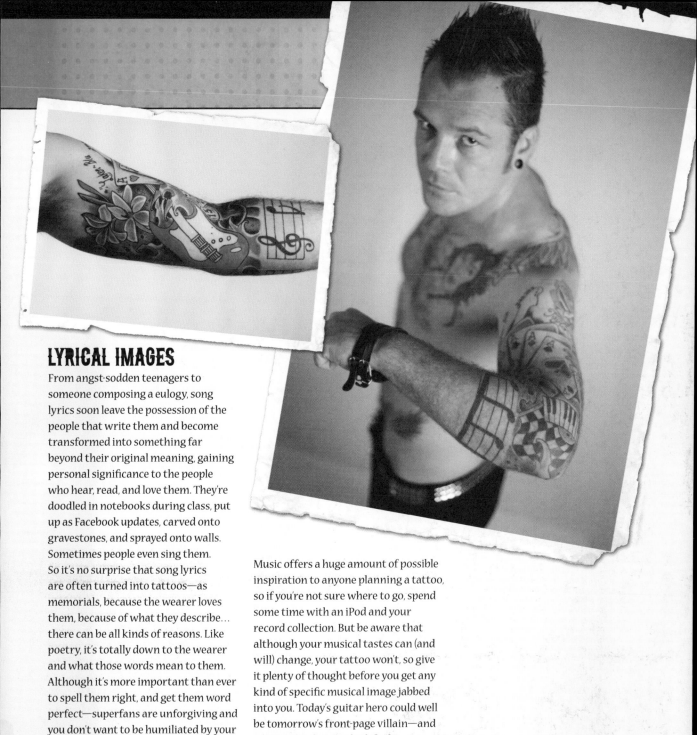

LYRICAL IMAGES

From angst-sodden teenagers to someone composing a eulogy, song lyrics soon leave the possession of the people that write them and become transformed into something far beyond their original meaning, gaining personal significance to the people who hear, read, and love them. They're doodled in notebooks during class, put up as Facebook updates, carved onto gravestones, and sprayed onto walls. Sometimes people even sing them. So it's no surprise that song lyrics are often turned into tattoos—as memorials, because the wearer loves them, because of what they describe… there can be all kinds of reasons. Like poetry, it's totally down to the wearer and what those words mean to them. Although it's more important than ever to spell them right, and get them word perfect—superfans are unforgiving and you don't want to be humiliated by your inaccurate ink.

Music offers a huge amount of possible inspiration to anyone planning a tattoo, so if you're not sure where to go, spend some time with an iPod and your record collection. But be aware that although your musical tastes can (and will) change, your tattoo won't, so give it plenty of thought before you get any kind of specific musical image jabbed into you. Today's guitar hero could well be tomorrow's front-page villain—and who wants that on their flesh?

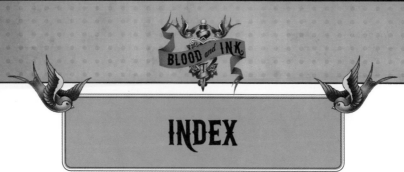

INDEX

CREDITS

T = TOP, B = BELOW, C = CENTER, L = LEFT,
R = RIGHT

BUENA VISTA TATTOO CLUB: 32L, 37BL, 56B, 57, 86R, 86TL, 86CL, 86BCL, 89T, 89B
CORBIS: 50 © Markus Cuff/CORBIS, 92 BCR © Ted Soqui/Corbis
GETTY: 54BR © AFP/Getty Images, 92 CL © Redferns, 92 BCR © Getty images, 92 BL © Getty Images
PHOTOSHOT: 92TR © AdMedia/Photoshot, 92TCR © Picture Alliance/Photoshot

ILLUSTRATIONS:
Landon Armstrong: 24 BC, 30 CL, 39 BL, 43 C, 45 BL, 74 C, 76 TL; **Molly Crabapple**: 18 BR, 19 TL, 43 TR, 18 BR, 19 TL; **Willem Jannsen**: 24 BL, 27 TR, 75 BR, 91 BL, 92 TR, 92 BR; **Emelie Jenson**: 24 TCL, 24 BR, 63 CT, 68 BR, 79 BL, 14 L; **Jane Laurie**: 26 CBR, 67 C, 92 TR; **Nick Solomon**: 22BL, 24 TCR, 29 C, 40 BL, 40 BR, 76 BR, 16 CT; **Peter Tikos**: 18 TR, 26 CB, 45 TC, 45 CR, 62 CB, 70 TL, 83 CR, 85 TR

MODEL PHOTOS TAKEN BY SCOTT FORRESTER AND RUSS THORNE, © QUINTET PUBLISHING LTD:
2 Aima (SF), 7 Tom (SF), 9B Arabella (SF), 9T Aaron (SF), 13 Rayna (SF), 14C Sally Bold (SF), 14BR Nicola McVey (RT), 15 Becky Seymour (SF), 16 Dan Gibson (SF), 16TR Maxine Johnston (SF), 16BR Edyta Lydon (RT), 17 Richard Evans, Skin Creation (SF),18TL (SF), 19T Vikki Davis (SF), 19B Neil Richardson (SF), 20BL Jay Starr (SF), 20BC Steven Burrow (RT), 20TR Chris Bacon (RT), 21T Steve Elam (SF), 21B Tasha

(SF), 22T Lukasz Dawudowkz (SF), 23 Darren Broaders (SF), 24BL, 24T Justin Burton (SF), 25TC Steph Hesketh (RT), 25TR Tasha (SF), 25BR, 27BL Rebecca Burton (SF), 26BL John Eddison (RT), 26TR Teri Montgomery (SF), 28B Nigel White (RT), 28T Neil Richardson (SF), 30TL Peter Czerniak (SF), 30BR Neil Richardson (SF), 31 Cara (SF), 32BR Chris Bacon (RT), 33TL Peter Johnson (SF), 33C jon mdc (SF), 33TR Andy Hussey (SF), 34TC Rayna (SF), 34BR Iris Knippels (RT), 35T Kerry Cunningham (SF), 35BL Hayley Matts (SF), 35BR Arran Tanswell (SF), 36TL Rayna (SF), 36CL Richard Warburton (SF), 36BR Emma Wroe (SF), 37TL Steven Burrow (RT), 37TR, 37CR Linggen Chan (SF), 40TC Vikki Davis (SF), 40TR, 41 Ashlie (SF), 42 Richard Lloyd-Mullen (RT), 44L (SF), 44TR Chris Bacon (RT), 45TL Justin Burton (SF), 46 David Barclay, London Tattoo (SF), 48 David Barclay, London Tattoo (SF), 49 Tetiu Huuti (SF), 51TR David Barclay, London Tattoo (SF), 51BR Donna Shew (RT), 52TL Elizabeth Barbazza (RT), 53TBL, 53BL Sakura Avalon (RT), 54Bl Richard Lloyd-Mullen (RT), 55 Tom Maschek (SF), 58BL Johny D Matthews (RT), 61T Nanna (RT), 62BL Ashlie (SF), 63BR Mick Tyreman (RT), 64 Cara (SF), 66BL Arseeli (SF), 67T Rebecca Burton of Black Cat Tattoo (SF), 67B Annette Sheard (SF), 69 Aima (SF), 70B A. Edwards (RT), 71 Sakura Avalon (RT), 72TL Jack Proctor (RT), 73TL Dave Wilson (SF), 73TR Sakura Avalan (RT), 74TR Darren Broaders (SF), 75T David Vaughan (SF), 76TR Billy (SF), 76CR Arabella (SF), 77TR John Eddison (RT), 77BL Lukasz Dawudowkz (SF), 78BL Michelle Williams (SF), 78TR Andy Kelly (SF), 79T Billy

(SF), 82T Dave Wilson (SF), 82B Cara (SF), 83T Scott Pinnington (SF), 83B, 84BL Ruth Berridge (SF), 84C Billy (SF), 85TL Anthony Smith (RT), 85B jon mdc (SF), 86BL Lukasz Dawudowkz (SF), 88T Teri Montgomery (SF), 88B Jarret Livingston (RT), 90BL Amy Lomas (RT), 90TR Daniel McClurg (RT), 91R Scott Pinnington (SF), 93TL, 93R Billy (SF).

MODEL PHOTOS TAKEN BY TATTOO ARTISTS:
6, 29T, 29B, 81TL, 81TR Dave Perry © Dave Perry; 10T, 10B © Sion Smith; 11T, 52BL, 52TR Boff Konkerz © Boff Konkerz; 11B, 72C, 72BR, 72CL © Guy Aitchison, Hyperspace Studios; 56TL Daralene Irwin © Tiffany Harvey; 68T, 68RC, 68BR Leah Moule © Leah Moule; 87T, 87C, 87B © Mr. Halbstark; 79B, 80T, 80B © Oddboy

AUTHOR'S ACKNOWLEDGMENTS
Huge thanks to all the artists who shared their time, expertise, and occasional eccentricities. Thanks also to the Quintet team for giving me such a fun project to play with—and cheers to Donna, Jane, and Scott for the Tattoo Jam adventures. Love to my late mum, Wahneta, who keeps inspiring me from the photo by my desk—miss you, maman. Finally, much love and thanks to my long suffering dad, sister, family, and friends, who have every right to gag me after all the tattoo tales, and most especially to my fiancée Madeleine for her support, and for stopping me sprinting out every ten minutes to spend all our money on new tattoos. Nice foo dogs!